Max Beckmann

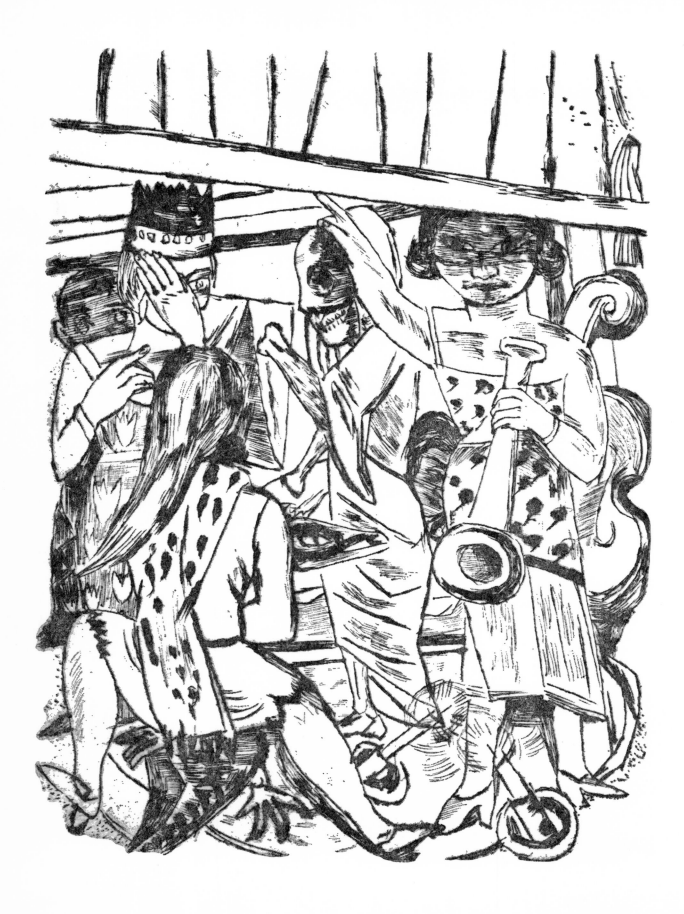

Friedhelm W. Fischer

Max Beckmann

Translated by P. S. Falla

Phaidon

Jacket (front): Odysseus and Calypso, 1943 (detail),
Jacket (back): Self-portrait with Horn, 1938

Phaidon Press Limited, 5 Cromwell Place, London SW7

Published in the United States of America by Phaidon Publishers, Inc.
and distributed by Praeger Publishers, Inc.
111 Fourth Avenue, New York, New York 10003

Originally published in German under the title *Der Maler Max Beckmann*
© 1972 by Verlag M.DuMont Schauberg, Cologne, Germany
Translation © 1973 by Phaidon Press Limited, London, England
All rights reserved

ISBN 0 7148 1577 2
Library of Congress Catalog Card Number: 72–83182

Printed in Germany by the Druckerei Gebr. Rasch & Co., Bramsche

If Beckmann's development as a young man is studied in terms of dates and achievement, it is clear that he made his way as an artist with extraordinary rapidity. He overcame the difficulties that attend any artistic career at the outset with amazing speed, despite the fact that there was no one to help him or to suggest the course that his endeavours might take. His family had had nothing to do with art: its background for many generations was one of profitable country pursuits. Even when his father, a Lower Saxon by birth, settled in Leipzig as a merchant the branch of trade in which he established himself had to do with flour-milling. His early death in 1894, when Max was only ten years old, meant a period of some uncertainty for the family.

These circumstances affected Max's schooldays in Brunswick, Gandersheim and Falkenburg, and may have encouraged his early determination to strike out for himself. At the age of sixteen he was able, after a struggle, to enrol at the art school in Weimar. During the next year or two he behaved like a man bent on success at all costs. In 1903, after three years at Weimar, he considered his training completed, and in 1905 he proved, with an ambitious picture, that he was capable of getting on by his own efforts. *Young Men by the Sea* (page 33), the work of an artist only twenty years old, excited admiration: it was shown in 1906 at the exhibition of the Artists' League, and was at once bought by Count Harry Kessler for the Weimar Museum. Beckmann was awarded the Villa Romana prize of a stay in Florence, and in the same year he married.

After his return from Italy he continued at a great pace. He built a house in Berlin-Hermsdorf and threw himself into the artistic life of Berlin: the very size of his pictures showed the measure of his ambition. Reactions to his work were mixed, but in general his success was not disputed. All his efforts went into extending and consolidating his position. In 1911, when he was twenty-seven years old, he was in the extraordinary position of having to deliver an opinion on the work of his exact contemporary Ludwig Meidner, to justify the award to the latter of a meagre bursary. A few years later, when Beckmann was going through the worst crisis of his life, Meidner's visionary paintings were to be a source of much inspiration to him; but this, of course, could not be foreseen in 1911.

Apart from the appreciation with which Beckmann's works were greeted, we may wonder in retrospect how it was that any young artist of his generation could make his way so quickly. In those days everything in the art world was in a state of flux. It was not a simple clash between old and new: the modern school in Germany had not emerged with any degree of clarity. In 1912 Beckmann had a sharp controversy with Franz Marc in the journal *Pan*, in which he attacked the obscurity of the modernists' aims and ideas. Whether or not his onslaught was justified, it makes us wonder once again about the source of Beckmann's inner security. Whether he was a conservative or merely had different ideas about painting, he certainly had no sympathy at this period with the German *avant-garde*.

There is one basic reason why this was so. Beckmann was not interested in problems of form. In his view the problems that mattered were those of the world itself, and they could not be solved by concentrating on the art of painting as such—to do so was to confuse the end with the means. He himself bent his whole attention on the object, believing that the rest would come of its own accord provided the artist worked hard enough and was sufficiently imbued with his theme. These are attractive views; at all events the young Beckmann put them into practice, and in later life he never substantially departed from them. Nevertheless, in that time of upheaval he underrated the difficulties that his self-sufficient course was bound to entail. The changes that take place in the modern world are hard to assimilate without a close examination of one's own resources and opportunities; but to rely exclusively on one's own powers is to court disaster.

It would be wrong to suppose that Beckmann was unaware of the danger signals. On the contrary, his passionate involvement led to sharp clashes with the outside world, but these were philosophical rather than artistic. A headstrong idealist, he threw himself with berserk fury into his work as a painter, while looking to philosophy for reinforcement. Even in philosophy he was over-impetuous: he could master almost any theory with speed and precision, but in an age when it was important to be blasé he lacked the necessary detachment. Full of toughness and heroic stamina, he had difficulty in discarding anything that had ever influenced him: it remained embedded in his consciousness for decades, even for life. This was true of his acquaintance with Schopenhauer and, through the latter, with doctrines of the latter-day antique world which he sought to illuminate in his own manner.

Possessing only fragments of his early diaries, it is hard for us to be certain of his development as a young man and artist, but we know enough to be sure that the picture of a self-confident drive towards success is wide of the mark. Perhaps his remorseless output of energy was in fact a form of escape. He was a man of great will-power and brilliant ability, and had no difficulty in striking a pose of self-assurance when he chose; but simultaneously, and beneath all this, he was sensitive, brittle and ill at ease. The combination of these qualities with headstrongness and a fondness for risks produced something in the nature of a time-bomb—a different picture from the conventional one of assured self-confidence.

Young Men by the Sea 1905

Let us revert to the painting that made his name in 1905: *Young Men by the Sea* (page 33). In this work he showed, as the phrase goes, *la griffe du lion*, and the fact that so progressive an art patron as Count Harry Kessler selected it for purchase indicates that the young artist was

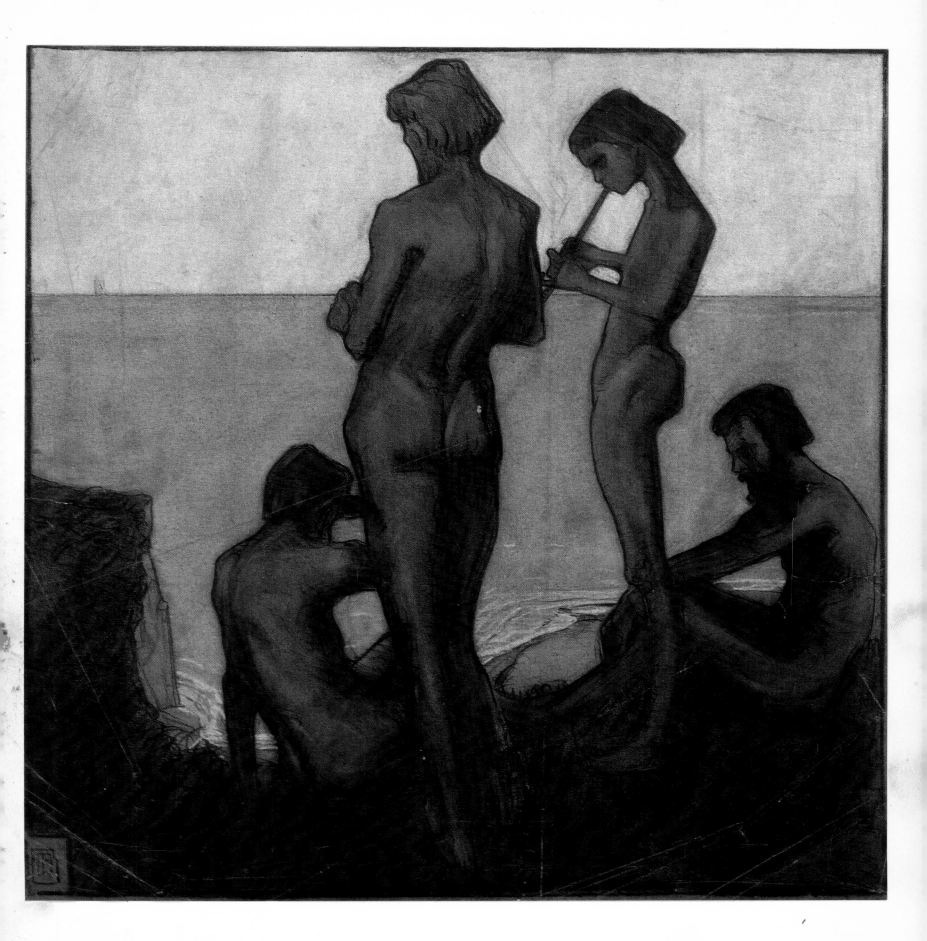

thought to have something new and individual to say. In retrospect we are chiefly struck by Beckmann's attempt to synthesize the contradictions of the time: the theme is imbued with sensitive idealism, but the execution is remarkably sober. Liebermann's influence appears on a par with that of Hans von Marées; the importance of the *Jugendstil* has sharply diminished, but the background of the picture shows a highly individual acquaintance with Neo-Impressionism, which in those days was scarcely known in Germany. However, the most impressive thing about this work is the boldness with which a tenderly classical frieze-composition is combined with a majestic sense of depth. This was a novelty and a declaration of intent on Beckmann's part. The theme of 'men by the sea' recurred again and again in his work, always from the point of view of the relationship between man and endless space. On the very eve of his death Beckmann completed his last picture of this kind, the central panel of the famous triptych *The Argonauts* (page 36).

The theme of this youthful picture is certainly a romantic one; but it is an outstanding achievement, in a painter twenty years old, to have resisted the sentimental implications that attach to such concepts as man and space, loneliness and distance. The flute-player on the right suggests the theme of art and embodies, perhaps, a faint residue of romantic emotionality. But the work is not meant to depict mankind and nature in a state of harmony, nor is it a lament over human isolation. Beckmann is content to see things as they are, and the true theme of the picture is that of endurance in a problematical situation.

The same subject is treated much more tenderly and with a trace of melancholy in a pastel of uncertain date, but clearly related to the picture of 1905 (page 7). This little study shows clearly the influence of the Symbolists and the *Jugendstil;* but as we have scarcely any material for comparison from the period before 1905, it is hard to say whether it is an isolated work or belongs to a phase of the painter's style. In any case it shows that he was well able to capture the impressive manner of *fin de siècle* art, and also, it seems to me, that he had assimilated the peculiar mood of this type of subject. This implies a degree of inward sympathy, whether or not it amounts to specific identification. The same mood recurs in a modified form in Beckmann's later work, and is especially strong in the paintings of his last years. These links with Symbolism are certainly to be taken seriously, though its effect on his painting was conditioned by a critical attitude on the artist's part.

To us the early pastel is of great psychological interest, evoking as it does the emotional, atmosphere which, in the 1905 painting, is relegated to clearly defined limits and contrasted with other possibilities. The artist's problem lay in the danger of reducing external experience to values of form and atmosphere—a danger made clear by a critical examination of the extremely skilful pastel. Although the work contains elements such as the horizon, the sea, a beach of interesting configuration and a group of men, and although something individual might be

predicated of all these, the ultimate object of the work is to produce a single, stylized effect. This effect is clearly intended to convey the essence of the scene; but if we look closely, it is open to question whether we are presented with more than the forced depiction of a mood in empty graphic language. Large surfaces sharply outlined, a dark foreground and a space suffused with a red glow as if from a perpetual sunset—by such devices the spectator is to be charmed into accepting, as though they were ultimate revelations, vague generalities concerning youth and age, music and thought, loneliness and distance. If he does not react in this way, the drawing may at least evoke memories, sensations and associations, but these are mainly his private affair. The drawing, if one looks at it closely, has nothing to tell us except about form and atmosphere; it depicts these in a masterly fashion, but clearly Beckmann wanted to do something more. It is true that his later works have a kind of significant reticence, as if it were the spectator's business to interpret them; but, as we shall show, these works of his maturity are enigmatic in a different way and on a different plane. The works he painted after 1905, in any case, are too full of content rather than too empty, and too aggressive rather than meltingly sentimental.

Resurrection 1909

In 1908 Beckmann conceived the bold idea of painting a modern version of the Resurrection of the Dead—not in arrogance, but in the context of highly serious conversations at the home of his mother-in-law, a theologian's widow. He also painted resurrections in later life, in which he shows concern to depict the collapse of a world which has lost its credibility, and to grapple with the problem of meaning. These objectives are also visible to some extent in the picture of 1909. At the same time the painter, now aged twenty-four, was clearly determined to see how far intelligence and genius could take him. Choosing a majestic vertical format, he pulled out all the stops, accepting with some audacity the fact that, with a subject so rooted in tradition, the great masters of old would, so to speak, be looking over his shoulder, while at the same time he would have to contribute something striking of his own. Undaunted and, it would seem, exhilarated by these difficulties, he succeeded astonishingly well in overcoming them and remaining the master of his own design.

At the first glance the imposing scene (page 10) may strike us as neo-baroque. The sharpness of Signorelli's treatment of the Last Judgement, or the massiveness of Michelangelo's, is only distantly reflected here; but there is a strong reminiscence of Rubens in the accentuation of the painterly aspect and the dynamic fusion of bodies and space. Beckmann clearly tried to emulate the vitality of the Flemish master, and he naturally made use of the resources of late Impressionism as displayed, for instance, by Lovis Corinth.

Despite its profuseness, the composition is uncomplicated. In the lower part of the picture we see the awakened dead rising hesitantly to their feet as the stiffness departs from their bodies. Their faces bear the imprint of remembered sorrow, and forebodings of the incomprehensible cast a fresh shadow of fear as they stand revealed in the eccentric play of light. But along with them, in the same section of the painting, are men and women in fashionable street clothes and party dresses, identifiable friends and relatives of the painter's. This produces a striking effect of topicality but at the same time confuses the impression, as it is not clear at first sight what relationship the figures bear to one another. One may be reminded of El Greco's *Burial of Count Orgaz*, but the interplay of vision and actuality is conceived here in a different way.

Behind the men and women in the foreground is a vast crowd of vaguely sketched figures, and in the upper part of the picture Beckmann really shows what he is capable of. He does not shrink from the problem of showing the arisen dead soaring up to heaven, and he manages to depict this in an artistically convincing way. As if drawn upwards by some tremendous force, the naked bodies rise into the air in two columns which seem to meet in a triumphant zone of supernal light. The billowing clouds, the radiance of the sky and the endless multitude of bodies dissolve in a vision of infinity.

We may well wonder if any painter of the time could have rivalled this achievement of the young Beckmann's; but the question is idle, since those who might have had the skill did not make the attempt. Beckmann's challenge did not confine itself to the baroque vision: he introduced a portrayal of himself, at the left edge of the picture, half turned away, with a cigarette in his hand. This seemingly irreverent touch is not a joke in bad taste, but rather a clue to the understanding of the work. If we consider the self-portrait in conjunction with the other figures from real life, particularly the two in conversation on the right, we suddenly realize that what Beckmann has done is to merge together two separate types of painting: a drawing-room discussion and a vision of the general resurrection as it may be supposed to figure in the consciousness of those present, by virtue of a long pictorial tradition.

Once this is accepted, many things in the painting may appear less bold and less provocative. Of course this is not the whole story. It is part of the artist's brilliant dialectic that he presents this viewpoint as something relative and not absolute, so that the dividing line between the different planes of reality is again obscured. While the painter smokes his cigarette and the two figures on the right converse placidly, another member of Beckmann's circle has thrown herself on her knees; and his mother-in-law, immediately beside him, looks upward in a matter-of-fact way, as though the scene were not surprising in itself and her own name might be called at any moment. Naturally Beckmann characterizes the figures in this way merely in order to show how they react to the supposed event. But this gives a different turn to the conversational setting, and, for some at least, the theme is transformed from imagination into reality.

Self-portrait 1914

Does the painter mean to suggest that there may, in all seriousness, be a resurrection of the dead? Apparently so, but we need not decide the point here. What is certain is that he was increasingly concerned with themes involving great transformations and fearful catastrophes. What preoccupied him in later years was not the vision displayed in the upper part of this picture; the baroque spectacle of ransomed souls rising triumphantly to heaven remained an allusion merely. Beckmann in this work shows himself for the first time as a stage director and manipulator of scenery; he was to return, after an interval, to the motif of the *mise en scène* and the mystery play, in the context of the baroque allegory of the world as a theatre.

Beckmann's second *Resurrection* (page 33), begun in 1916, is even more imposing in size than the first. Remarkably, it is oblong in shape, being nearly five metres broad and barely three and a half metres high. It is fantastic in conception and was never brought to completion, but what can be seen today of the huge, uncanny picture, underpainted grey on grey, is sufficient to evoke traumatic reactions. The painter takes the customary representation of the Last Judgement and tears it in two like a sheet from a picture-book. Heedless of scale and proportion,

The Mortuary 1915

he intensifies the sense of horror in a way possible only to an artist of our century. We will not examine in detail how this is done, but, apart from the quite new and extremely mannered style, the effect of shock is due partly to chaotic exaggeration and partly to a radical destruction of perspective. We see here clearly enough how a world can disintegrate and cease to be; but, not content with that, Beckmann shows with fearful insistence how the bodies emerging from the earth struggle in vain for consciousness, how ideas and a sense of time and place elude them, and how panic springs directly from this paralysis of the understanding.

This approach is clearly related to the lower part of the *Resurrection* of 1909, where the awakening dead are shown in a benumbed and nightmarish condition; but in that picture we soon forget their plight in the comfort and liberation of the opening heavens. In the 1916 painting there is no such upward look, no comprehensive vision of any kind. Instead, the artist shows what happens when familiar projections lose their power and disaster can no longer fade into consolation. We are not confronted here with judgement, reward or damnation, but with the dissolution of the whole framework of our mental processes. There is no 'on high'—the

choice of an oblong format has already seen to that—nor is there any background. All that can be seen is featureless space, a disconsolate emptiness and a dark, menacing star. The artist, too, is no longer the smart dialectician. As in 1909, he has painted himself and a few friends into the picture, but this time they are cowering in a crevice of the earth, like soldiers in a trench.

When Beckmann began his second *Resurrection* he was in a parlous state. In the autumn of 1915 he had been invalided out of the army owing to a nervous collapse. Having apparently recovered he attempted to resume work as a painter, but it soon became clear that the collapse was only the beginning of a profound crisis that was to persist for more than a decade. It is hard to reconstruct what happened to him in those years, but we know that he found it impossible to revert in any way to civilian life as it had been before the war. He returned neither to Berlin nor to his wife, who had embarked on a career as an opera singer and was living in Graz. He settled with friends in Frankfurt, first making use of Ugi Battenberg's studio and later hiring one of his own in the Schweizerstrasse.

As we have already seen, there were contradictions in Beckmann's work and character, and his vitality was not so unshakable as it had seemed in the pre-war years. His first instinct was to overcome these contradictions by driving himself ruthlessly, but by 1914 at the latest he seems to have realized that the ground was not firm under his feet. A change of style had begun to declare itself, only as far as his drawing was concerned, as early as 1912; this became clearly marked immediately before the war and is disquietingly apparent in works executed while he was on active service. The evolution was a continuous one, in the last resort the result of the pressure of ghastly events. Meanwhile he had still to cope with the key problem of redeploying his resources as a painter. This he solved in the course of an acute struggle during which he accepted very little advice from outside. It was not until about 1918 that he began to achieve success: in his famous picture *The Night* (page 15) he found a formula in which he was able to continue working. It shows a strong dependence on graphic style, the object being focused in almost unendurable clarity. At the same time it was recognized as embodying an eminently modern concept of the artist's art.

Apart from such developments, the chief thing Beckmann's friends must have noticed about him was that his reserve had become greatly intensified since his return from the front. He was still a young man and, little as he let the world see his difficulties, they must have radically transformed his being. In discussing his inner crisis it is important to treat it neither from a purely artistic nor from a purely psychological or medical standpoint. As always, to Beckmann himself it was ideology that mattered first and foremost.

In his *Confession, 1918* he wrote: 'So the war is reaching its unhappy end. It has done nothing to change my idea of life, only confirmed it.' This may have a complacent sound, but it is important to realize what the 'idea of life' in question was. In all probability it lay close to the

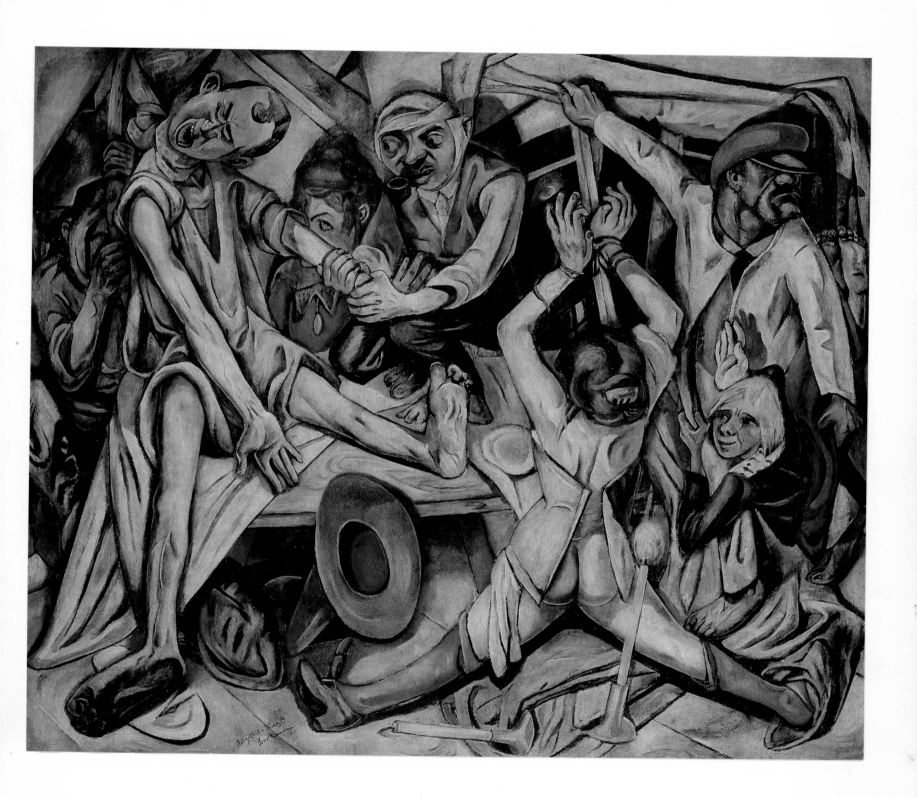

pessimism of Schopenhauer, set in a keener light by images and parallels drawn from the Gnostic philosophy of late antiquity. In theory such ideas were no doubt familiar to Beckmann before the war, but it was his experience at the front that determined his existential relationship to reality, an attitude which for years to come was to cause him torment and visionary persecution.

On the outbreak of war Beckmann enlisted as a volunteer medical orderly and was sent first to the East Prussian front. Here he began to study the war with passionate interest as a visual sensation, similar no doubt to the catastrophes which, in a kind of premonition, he had depicted from 1908 onwards: the *Deluge*, the *Scene from the Destruction of Messina* and the *Sinking of the Titanic*. He set about eagerly drawing scenes of destruction, horses shying, men in violent movement and with distorted faces. But the war did not conform to the dramatic schema he had imagined. In Flanders in 1915 it turned into a machinery of horror that no one could have foreseen and that those who lived through it scarcely understood. Beckmann tried to do so, and soon suffered a breakdown in consequence. The crude, wordless routine of butchery, the maimed bodies, the operating-room and the death-chamber, the rigid corpses and the screams of nameless suffering—all this did not add up to the exhilaration of catastrophe but to a sum of terror, the precision of which made it all the more inconceivable.

The fact that things were happening to humanity which it had no means of understanding, and that human beings accepted their fate as if they were cogs in a machine—this, together with innumerable scenes of horror, continued to haunt the artist throughout his life. The *Resurrection* of 1916 was no doubt a first attempt to come to grips with the horrific vision. When he ceased work on this huge picture in 1918, he transferred his problems to the mysterious painting *The Night*. Many have puzzled over the interpretation of this work, which shows the enactment of a fearful deed—in a dream or in real life?—with dumb, clockwork precision and without any apparent clue to its context or meaning. Clearly the artist's purpose in painting it was in fact to confront the spectator with problems for which tradition affords no solution. On the surface the picture is merely a blood-and-thunder scene of robbery and torture in a narrow attic, but Beckmann leaves us in no doubt that it has an allegorical meaning, and that of a double kind. Not only are the victims hopelessly isolated and at the mercy of violence, but we feel that the murderers are not in control of their own actions either. They appear to be in a trance, obeying perhaps a preconceived plan, or some inner logic of the situation, or an external force of which they understand nothing. The presence of certain motifs from *The Mortuary* of 1915 does in fact provide a hint, but even without it we might have guessed that this bloody event, devoid of sense yet seemingly inevitable, is a parable of the machinery of war.

Beckmann is clearly asking what kind of a monstrous law it can be that periodically engulfs man, society and the whole of creation, despite all the assurances of free will. We know from

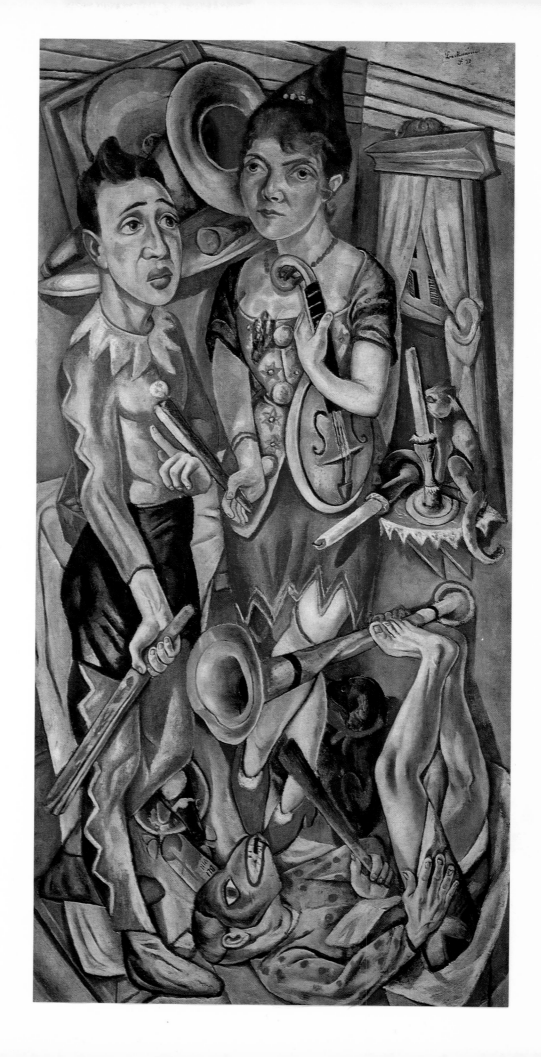

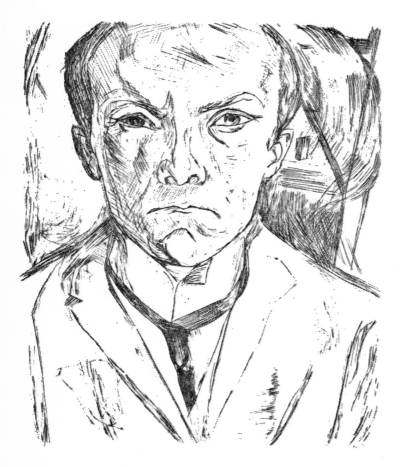

Self-portrait 1918

various remarks of his that this question was indeed dominant in his mind, and that he wished to force the spectator to an act of painful recognition. In 1919, as Reinhard Piper has recorded, he made the significant comment: 'My pictures are a reproach to God for all that he does wrong.' At the same time it is noteworthy that he uses Christian imagery in *The Night* in the shape of the two candles, one upright and one knocked over, next to the lower edge of the picture.

Carnival 1920

In the early twenties Beckmann, painting in his new style, gradually gained acceptance with a wider public. His admirers were not always the same as before, and they probably belonged to a large variety of circles, but they began to include friends of the *avant-garde* movement. Beckmann's critics still regarded him as an odd character, too much of an egoist to admit of classification, but the existing 'schools' did not present a satisfactory picture either. Little was

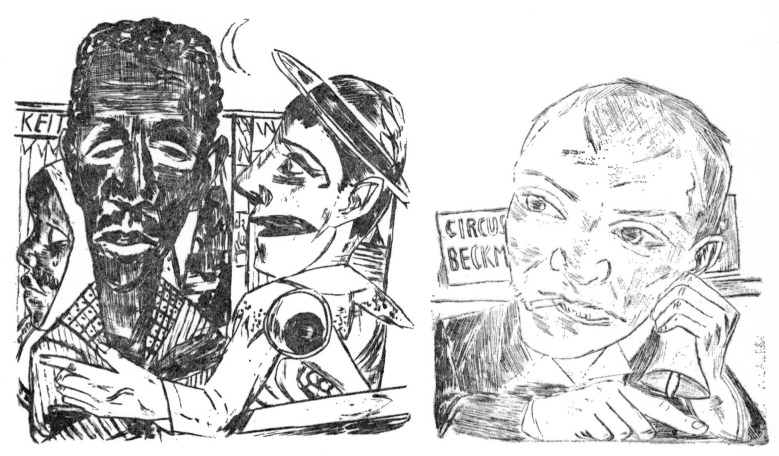

The Negro (left) and The Barker (right) 1921

left of the *élan* of progressivism; changes and difficulties were seen on every hand. Expressionism seemed to have had its day. The classic period of Cubism was no more, and many were shocked by the way Picasso was going. Only in the Bauhaus, it seemed, was salvation to be found, if one could accept its peculiar dogmas. In this uneasy situation it was bound to arouse attention when an artist of Beckmann's calibre came forward with a new, aggressive style, hard as steel in its self-consistency. No doubt critics asked themselves how Beckmann had arrived at this style, and what aspects of the contemporary movement he had thought fit to embody in it. We will make an attempt to answer these questions.

The painting *Carnival* of 1920 (page 17) poses abundant problems at the outset. The extreme vertical format is disconcerting and more reminiscent of a late Gothic panel than of twentieth-century progressive art. The picture surface is crowded, the figures highly suggestive. However, we will leave them for later inspection and, as far as this is ever possible with Beckmann, will first examine the work from the purely formal point of view.

The first thing we notice is the affinity with Cubism, especially if one casts a glance at the picture as a whole with its splintery articulation of forms. If we look more closely, we find that every form and every surface has a peculiar fractured quality. This even extends to what ought to be organic shapes, so that patches of human skin or drapery look as if they had been artificially stretched over the stiff, brittle bodily structure which underlies them. This effect is accentuated by the unnatural bending or sprawling of certain bodily forms, such as the left leg of the creature lying on the ground. We are made to feel, whether or not at a conscious level, as though our own limbs were fractured or dislocated in the same way. This assault on our comfort is of course more than a purely formal effect. Such deformations with an emotional content are rare in Cubism and really belong only to the movement's first beginnings, but they are persistently important in German Expressionism.

This thought leads at once to further considerations. The use of colour, too, is aggressive and emotional rather than analytic. Parts of the picture remind us of Cubist works with their reduced colour range and shallow application of paint. This may be said, for instance, of the drapery behind the clown on the left, and the curious arrangement of two bottles and a plate under that figure's knees would not be out of place in a Cubistic or Futuristic work. However, the gamut of grey-green-brown tones is dominated in the picture as a whole by reds, blues, light greens and yellows. Red is used with especial emphasis, not only in surfaces but in individual accents such as the eye of the animal mask, the harlequin's weapon (a wooden bat composed of separate laths) and other parts of the cretinous masked figure. The use of red in various shades throughout the picture is expressive and somewhat discordant, as they do not harmonize with one another. In conjunction with other motifs, this soon produces an effect of discomfort. The reds in general are hectic, unstable and aggressive—once again an Expressionistic phenomenon.

The composition in space, ingenious and artificial as it is, leads to a similar observation. Beckmann has here executed a brilliant variation on the modernistic theme of the relationship between space and surfaces, but he does so without recourse to an abstract dimension. His composition preserves the memory of a room in conventional perspective, and the tense spatial relationships are created against this background. It is not only the breaking up of lines that disturbs the spectator, but the masterly re-ordering of space, expressive in its deformity. The relation between the window-frame and the wall, the cornice and the curtain-rod at a wrong angle to each other, the tilted brackets, the floor obeying different laws from the ceiling—all this makes us feel as though space had been taken apart and put together inexpertly. This too is an emotional feature of Expressionism, in which the normal order of things is broken up but is not replaced by a new, homogeneous structure. On the contrary, Beckmann's object is to produce tension. Everything is stretched, pushed and pulled about; objects, as well as animate figures, play their part in creating a scene of spatial chaos.

This, of course, is not the whole story. The artist introduces concrete structures where they suit his purpose, such as the very interesting composition of fragmentary objects under the main characters' feet, where the floor should be. The impression that they are standing on solid ground is certainly due to the application of Cubist doctrine. Perspective is replaced by an arrangement in which 'in front of' and 'behind' are of little importance; space, surfaces and bodies affect each other in a relativizing and structural manner. If we ignore the nature of the objects as things, we may see the composition as a more or less abstract one which is both stable and elastic.

It is curious that, immediately above the intricate assemblage of underfoot objects, the artist has introduced a startling element which rivets the attention. The yellow trumpet projecting obliquely into the room is certainly intended to have a suggestive effect and to bring the spectator face to face with an emotionally charged pictorial universe. The two stylistic tendencies we have examined are probably both necessary for the total effect. But for the lower part of the canvas, with its relative indifference to space, the directional effect of the trumpet would be partly lost and we should probably not feel, as we do, that it is sticking out of the picture towards us. And, on the other hand, if it were not for the tricks of perspective the work would lose its rhetorical effect, the insistence with which it refers us to people and things and not merely to artistic forms.

The differentiated grid of space and surfaces, invented by Cubism, was of importance to Beckmann only as a kind of auxiliary construction, a framework or background against which he could undertake new experiments in perspective. The combination and compenetration which results is dominated by the artist's purpose of using the most modern discoveries in order to preserve or recreate the illusion of space. Spatial depth is existentially important to Beckmann, as the dimension of free movement and individual assertion. In this way, and not least by means of the projecting trumpet-mouth, he secures for his figures a modicum of living space. Little enough indeed: barely room for a cramped gesture or two, as they stand literally with their backs to the wall. But it is just this situation which expresses the artist's main theme: the self-assertion of the individual against the abstract picture-surface on the one hand and infinite, directionless space on the other. Both these embody the threat of anonymity, against which Beckmann's pictures constitute nests of defence and resistance.

Before pursuing this theme we must point out a third stylistic tendency, perhaps the most important of all. At all events, it was by bringing this tendency to the forefront that Beckmann placed himself at the head of a modern artistic movement under the banner of 'New Objectivity'. It has also been called (by G. F. Hartlaub) 'magic realism', which seems to me more germane to the present context. The trend in question was making itself felt around 1920; Beckmann

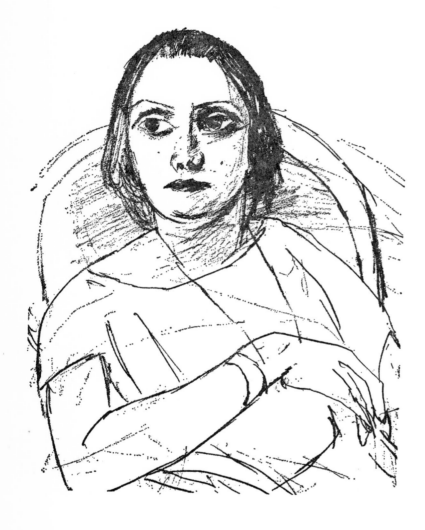

Minna Beckmann-Tube 1923

gave it a decisive impulse, although he soon went his own way again. His attitude to Cubism and Expressionism was different: he only used as much of the former as he needed, and he never used the latter for its own sake. From 1917 onwards, on the other hand, 'Objectivity' was his most important principle. This does not mean the commonplace objectivity that regards the external world as the sole reality: in Beckmann's view, our first duty is to become objective about our inner selves, by dint of analysis and austere reflection. In the preface to a catalogue of 1917 he sums up his programme in three demands: the artist must be a child of his age, he must be naturalistic towards his own self and objective as regards his 'inner vision'. A picture like *The Night* (1918–19) may be regarded as exemplifying his intentions. Far from excluding

each other, the commitment of a visionary and the ruthless clairvoyance of an observer must work together for a single end.

In the essay quoted above Beckmann continues: 'I am a lover of the four great painters of male mysticism: Mälesskircher, Grünewald, Bruegel and Van Gogh.' This certainly goes beyond what we understand by New Objectivity, but his link with the progressive painters of that school is a very important one, namely the conviction that we can approach the world critically only if we understand and portray it in its concrete aspects. To put it another way, the everyday world of encrusted material things will not give up its secrets but will only become more ghostlike, as long as people and objects are withdrawn from the scope of artistic reflection and replaced by abstractions.

In *Carnival* we are indeed brought face to face with the actual world of objects. By pregnant draughtsmanship and the suggestion of material properties, each object is brought to life in a challenging, almost importunate fashion. Thanks to this technique, material things are not only present in an intensified way but, paradoxically, are endowed with a background and significance which may perplex the spectator. This recalls the work method of the Metaphysical painters and of a similar later form of Surrealism. However, Beckmann is not concerned simply to produce an effect of alienation. The representational devices which suggest significance in places where one does not usually expect it do not function in a ghostly vacuum but are tied to a highly specific and densely woven 'text'. Beckmann detests idle mystification. He fits statements to objects, and makes material symbols out of the fragment of an anonymous material world.

The truth of this may be discerned by intuition, but a good deal of knowledge and investigation is required to substantiate it fully. Anyone who has seen many pictures of Beckmann's knows how fond he is of such 'properties' as a mirror, a candle or a wind instrument. It is easy to write these down as symbols, but are they exactly that? To answer this, let us study the fairly manageable motif of the candles, one upright and one overturned, on the bracket under the window in *Carnival*. They also occur in *The Night* and in many other of Beckmann's works; in fact, the candle is one of his favourite 'object-symbols'.

Turning first to pictorial tradition for a clue, we find the ancient motif, still lively in the nineteenth century, in which the candle is a symbol of human life: it may be knocked over or blown out or fall of its own accord, and the extinguishing of the flame represents death. From the fifteenth century onwards, innumerable *Vanitas* still lifes show us a fallen or guttering candle with this significance. Beckmann of course had seen many such pictures, and there is no doubt that he understood their allegorical meaning. In a still life of his own in 1945 he painted a skull beside an extinguished candle in the time-honoured manner. In his well-known *Fallen Candle* of 1930 (page 34) he added the familiar *Vanitas* component of a mirror, as well as a book

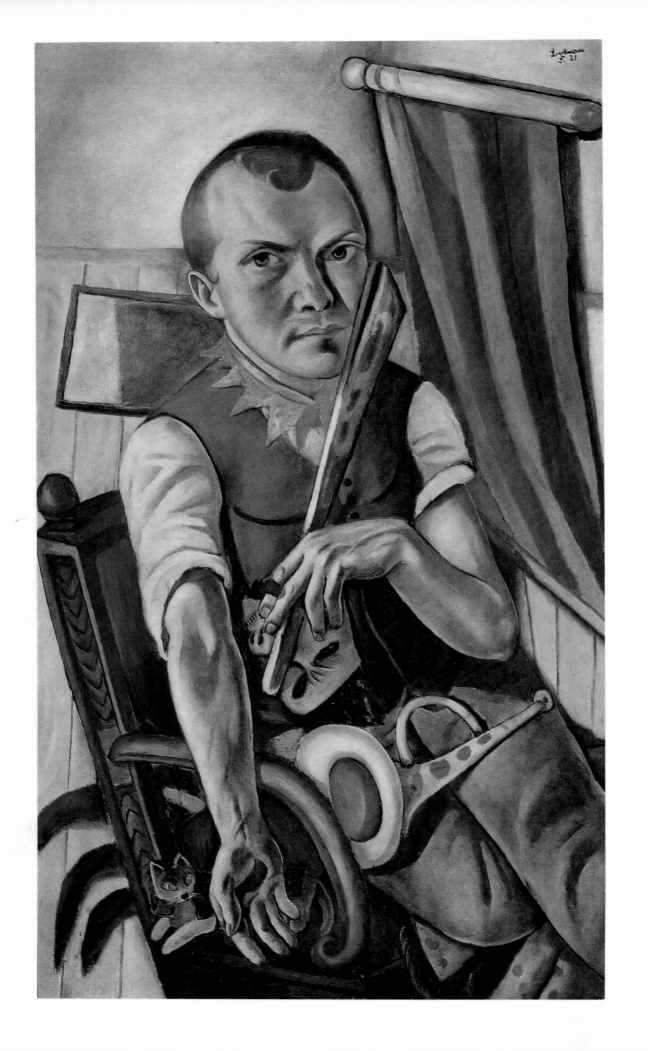

Self-portrait as a Clown 1921

inscribed 'Eternity'. This symbolism is perfectly clear, and we are justified, at all events experimentally, in adopting it as part of our interpretation.

The purpose of a *Vanitas* is to act as a *memento mori* (hence the skull) and to recall the vanity of earthly things, exemplified by the transient visions in a mirror and the vanity (in a related sense) of the person using it. In addition, musical instruments are traditionally a part of the theme: string instruments for song, dance and gaiety; wind instruments—especially trumpets—for earthly fame, as transient as the rest. Doubtless there is a link here with the trumpet in our picture, but we must go carefully. The trumpet motif plays many parts in Beckmann's work, and its use in each case requires analysis. The first point to note in the present instance is that it is not a real trumpet at all, but the kind of horn used in a carnival procession.

This brings us back to the title of the work. Many of Beckmann's pictures are called *Shrovetide* or *Carnival*, and they include many emblems of vanity and folly, as did those of James Ensor before him. Many proverbs and satires speak of the world as a madhouse, and since the late medieval *Ship of Fools* it was common to associate human folly in general with the grotesqueries of a carnival cortège. In the baroque period this thought was extended into a parallel between the world and a comic stage: in the sight of God or eternity the petty doings of mankind, in fact the whole of human history, were no better than an idle farce.

In the early twenties, Beckmann found this last comparison peculiarly appropriate. Indeed he went further than the baroque satirists by taking as his target not only mankind but the director of the theatre himself: 'My pictures are a reproach to God for all that he does wrong.' The *Vanitas* and carnival allegory was thus given a radically new purport; but for our purposes, the point is that the painter used its symbols in their traditional sense. He was not the only man in the 1920s to use the commonplaces of moral theology and baroque satire in the service of an artistic conception that was highly critical of his own times. Bertolt Brecht is an obvious parallel: in him, too, we find the aim of the satire reversed, or rather extended, with some residual tension between religious tradition and radical aspirations. If Brecht's style owed much of its effect to echoes of old service-books and other edifying literature, this too can be paralleled in Beckmann. From about 1917, for instance, his paintings contain curious reminiscences of late Gothic panels. Mälesskircher, the supposed Master of the Tegernsee altarpiece, who is mentioned in the foreword of the above-quoted catalogue, was almost certainly one of the prime influences here, and the Master of the Karlsruhe Passion may have played an intermediate role. Towards 1920 Beckmann seems to have been chiefly inspired by pictures of the mid-fifteenth century, as regards not only composition but also concentration on the world of external objects. The precise, almost obtrusive delineation of objects, and their function of providing space within a composition whose relation to reality is uncertain, are characteristic features of late Gothic painting in a dramatic phase of its stylistic development. To revert to the comparison with Brecht,

this should not be pushed too far. The poet's objectives were clearly different from Beckmann's, but the two men set out from similar positions; both were artists of solitary genius, and both maintained a lively yet reflective attitude towards tradition, in which they showed themselves quite different from contemporary modernists.

To sum up, we may say that around 1920 Beckmann was making such use as he chose of the stylistic tendencies of the day, and gave a decisive impulse to one of them, but his work did not fit neatly into any single category. Although in a new guise, it continued to be based on the pictorial tradition of the past; this left him enormous scope, and he gradually developed an individual manner which called for new standards and methods of interpretation. His basic approach did not alter from now on, despite occasional variations and a succession of interesting stylistic phases. He sat loosely to the artistic fashions of his time, which by degrees became of minor importance to him. He continued to take seriously his own injunction to be a 'child of one's age': political and social changes affected him like a seismograph, though in all cases they were refracted through his own personality.

Personal relationships and experiences were also important to him in the twenties. *Carnival* has a personal as well as a symbolic significance: the two upright figures are friends of Beckmann's, who never met in real life: J. B. Neumann, the art dealer, and Fridel Battenberg of Frankfurt. According to a reliable tradition, the curious figure on the ground, with the animal mask and with his legs in the air, represents Beckmann himself. This may seem strange, but a comparison with other paintings shows that at this period he was fond of depicting himself as a cretin. A striking example is the *Family Portrait*, also of 1920, and we shall come across other instances.

A grotesque identification of this kind raises various problems. In the present case we wonder, first of all, what the masked figure is doing. As it is carnival time, no doubt the action is a joke of some sort, and the fact that it looks so cramped and pointless is part of the discomfort of the situation as a whole. The other figures reflect this discomfort by their perplexed and self-conscious air. All three are unskilful at enacting their parts in the carnival jollification; they look frustrated, perhaps because they cannot throw off their memories. In fact the *Vanitas* symbols, however obscure their precise meaning, show that Beckmann did not intend a picture of carnival jollity but a macabre scene of the world's folly. The contortions of the cretinous figure in the mask are not a mere convulsive reaction of embarrassment, but are touched with defiance and despair. Similar attitudes of protest may sometimes be seen in children; here, however, their target is none other than the director and animator of the world's theatre of the absurd.

We shall have occasion to revert to the theme of buffoonery in Beckmann's work: it does not occur in isolation, but in the context of a group of metaphors united by the central notion of the world as a comic theatre. Beckmann was fascinated by actors and showmen, by roles, costumes

and attributes; the *Comédie italienne* and the *Hanswursttheater*; circus life and all the oddities of the fairground. He depicted these last in manifold detail in one of his best portfolios of graphic work, the *Annual Fair* (1921). Unlike the set of lithographs entitled *Hell* (1919), his etchings of the early twenties do not relate to a particular point in time, to specific horrors or social crises. Conditions in Germany had settled down to some extent: misfortune no longer stalked the streets but had to be looked for in obscure places where society tolerated it and where injustice was the citizen's everyday lot.

The world of fairs and circuses offered scope for social and psychological comment, and Beckmann made use of the peculiar tension that arises when a grotesque performance is seen from the viewpoint not of the spectator, but of those who earn their living by it. In *Nigger Dance*, *The Wrestlers* or *The Tall Man* this tension is increased by the fact that we are shown not only the performers but also the reactions of a fairly rough audience. Beckmann took especial care with *The Negro* (page 19), a remarkable work of which impressions were made at three different states. In the second and third of these, isolated letters and syllables appear, and on a closer look we perceive that the disjointed fragments WI and KEIT belong to the word *Ewigkeit*

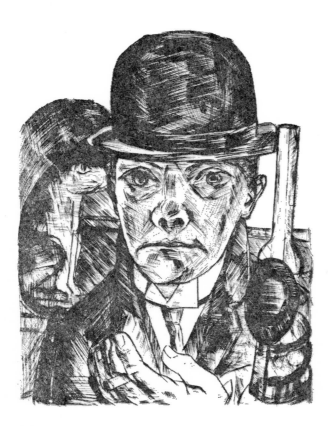

Self-portrait in a Bowler Hat 1921

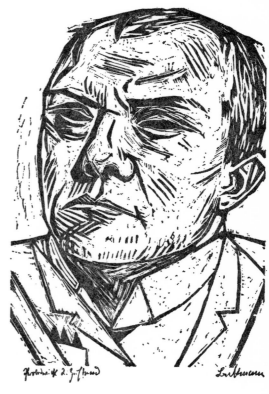

Self-portrait 1922

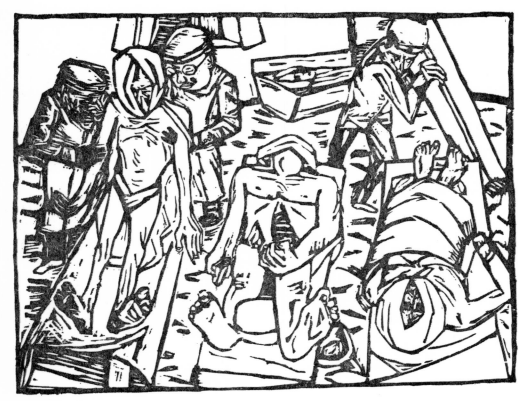

The House of Death
1923

[eternity], which Beckmann frequently introduced into later works. He was fond of mysterious hints of this kind, which sometimes provide a clue to the meaning of his pictures and which—half-obscured, illegible and fragmentary as they are—have a symbolic significance in themselves. They denote, in fact, the enigmatic quality and the deliberate mystification which, by the middle twenties, had become a salient characteristic of Beckmann's art.

There are various reasons for this love of mystery and camouflage. In the first place, we feel that Beckmann's own role in the world is a matter of increasing perplexity to him. There is a hint of this in the first engraving of the *Annual Fair* series, where he has portrayed himself as *The Barker* (page 19). Raising a bell in one hand, with the other he invites the spectator's attention with a restrained but effective gesture. The self-portrait expresses reserve and gentleness. The head is held at an angle as though he were deformed; the facial expression is an elusive mixture of challenge and distrust, with a suggestion of melancholy. We may be reminded of a repressed, bewildered child that knows better than its elders but is obliged to keep the knowledge to itself. Behind the barker's head is a board inscribed 'Circus Beckmann'.

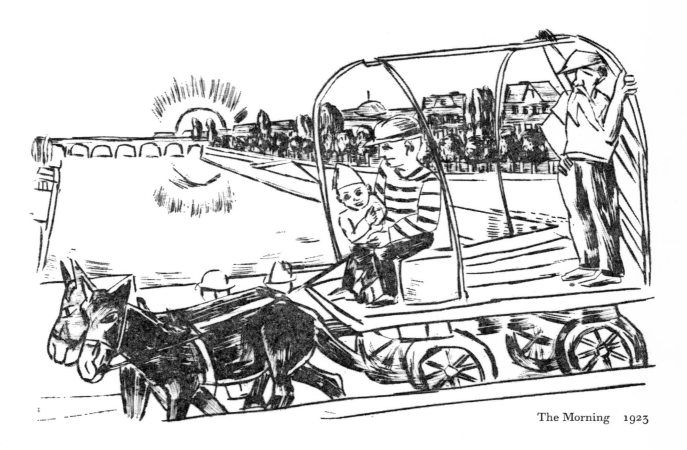

The Morning 1923

Self-portrait as a Clown 1921

Beckmann's mood in the early twenties was certainly one of frustration and melancholy. The spirit of doubt and self-mockery is felt to an almost repellent degree in the deformity and infantile alienation of the self-portraits of this period, the objectivism of which is blended with an ironical capacity for romantic self-pity. Like Brecht in the famous poem *Vom armen B.B.*, Beckmann found artistic inspiration in this latter tendency, and that may be one reason why he indulged it. His *Self-portrait as a Clown* (page 24), painted in 1921, is an interesting example which, following Brecht, might be entitled 'Poor M.B.' It also shows admirably how discordant feelings and incongruous circumstances can be expressed in terms of a clear, suggestive formula. This is achieved by the uniform reduction of all the picture's components to a mode of vision and representation which may be approximately defined as naïve or childlike. The infantile strain which we have noticed several times before is here discernible not only in the painter but in his surroundings. The chair, the carnival trumpet and the peculiar curtain are all imbued with this feeling. The treatment of space also has a primitive air, although here there is an element of

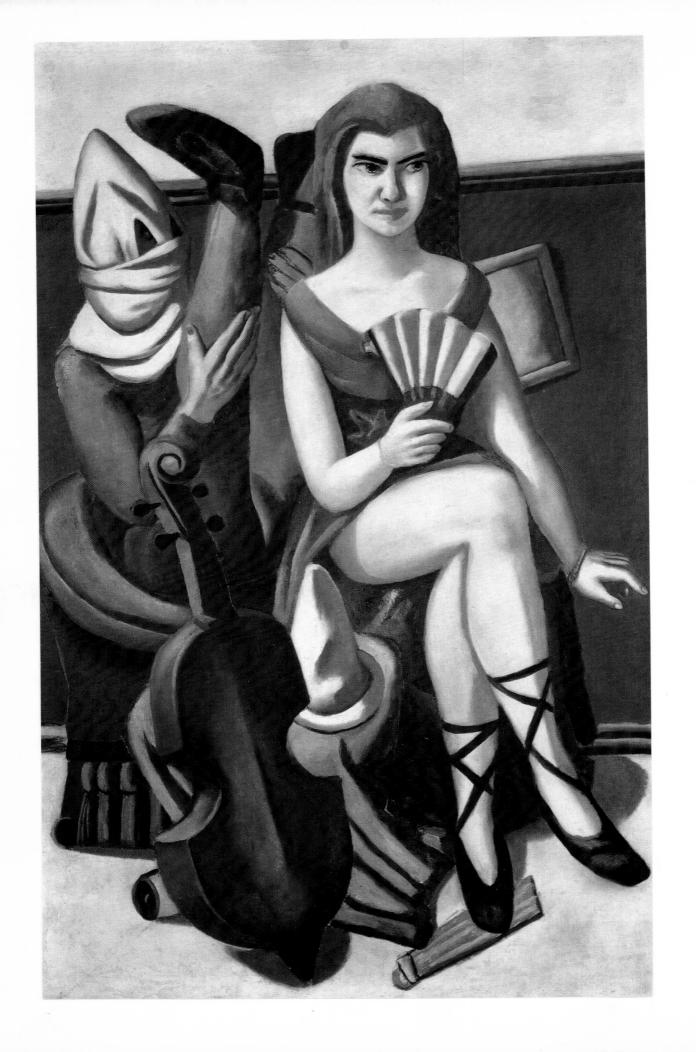

Pierrette and Clown 1925

skilful camouflage, reducing or concealing the effect of depth so as to maintain the frontal impression of the whole. The influence of late Gothic pictorial work is again manifest and can be pursued by the expert in striking detail. Curiously enough, the borrowing does not appear superficial: this is because it was not a matter of deliberate imitation but, as always with Beckmann, was dictated by the content of the work, what we may call in this case its 'pseudo-sacral' approach.

The picture in fact evokes two types of traditional theme, in each case by means of subliminal associations. The chair, the curtain, the fixed glance and the more or less frontal upper part of the body combine to suggest the image of a ruler on his throne, and the work might be taken as a sarcastic parody of a regal portrait of this kind. In addition, there are clear references to the devotional themes of the Mocking of Christ, the Agony in the Garden and the Man of Sorrows. This is especially clear if we compare the position of the arms and hands with late Gothic works portraying these subjects. The painter holds his wooden bat with the same gesture as Christ, set on a throne by his mockers and holding a reed for his sceptre as 'King of the Jews'. The outstretched right arm and the open hand are directly reminiscent of the crucified Christ displaying his wounds, and the heavy shadow in the palm seems designed to accentuate this.

It is perhaps impossible, and in any case not necessary, to analyse and compare the various levels of significance of this painting. However, the basic tension between the depiction of the artist as a clown and the suggestion of a state portrait seems to me typical of Beckmann's attitude towards himself at this period. It is another question how far the painter equates his own sufferings with those suggested by the themes from sacred art. Clearly a transposition of some kind is intended: we meet it in later works and on a different level, particularly in the triptych *The Actors* of 1943, where Beckmann depicts himself as a king undergoing a kind of sacrificial death.

In the 1920s we hear no more of the sacral theme, and the influence of late Gothic panel painting diminishes after 1921. Instead, as Beckmann returned to landscape we find him deriving vivid inspirations from the naïve style of Douanier Rousseau. His development at this period is illustrated less by his painting than by his graphic work, especially etchings and woodcuts in 1921–5: these are not a mere accompaniment to his pictures, but explore fresh possibilities and prepare the way for change. An important part was played by the invention of pictorial formulae charged with symbolic force, as opposed to the mere invocation of traditional motifs.

Beckmann's idea of himself underwent a change in about 1922, as may be seen from a woodcut self-portrait (page 27): the mood is still one of alienation, but the sensitivity and sham immaturity are replaced by a blunt, coarse attitude. This new persona, real or assumed, is characteristic of a number of later self-portraits which remind the satirically inclined of a boxer

or wrestler. A comparison with the insecure yet admirable *Self-portrait in a Bowler Hat* of 1921 (page 27) shows how nearly extremes meet, on occasion, in Beckmann's work.

In 1923 he executed a large number of fine drawings and engravings. These began with a curious reversion to the past in the woodcut *The House of Death* (page 28), a new treatment of the war theme which closely resembles the etching *The Mortuary* of 1915. The new version shows an artistic power and finality that is rare even in great masters. We may suppose that the purpose of this impressive work was to draw a line under the past and to mark the point in time at which the artist felt he had shaken off the trauma of his war experiences, which in fact did not assail him again for decades.

If we are looking for a positive counterpart to this work, indicating the mood of a fresh departure, we may find it in the etching of 1923 entitled *The Morning* (page 29). This belongs to an important series of townscapes, but it transcends the normal definition of the genre. It is a view of Frankfurt showing the Main spanned by two bridges, one in the foreground with a horse-cart crossing it. There are still touches of the naïve manner, for instance in the horses and the spick-and-span houses that might have come out of a box of bricks. But we are no longer disconcerted by this; the objects fit smoothly into the clear, unpretentious delineation of the town and river. The tension that forms the central idea of the work also appears effective and natural. The two main motifs, the cart with its occupants and the rising sun, are separated by the long perspective of the river, but the eye catches their symbolic relationship at once. Perhaps intentionally, the human figures represent three generations: a man and a boy on the box in front, and an old man standing at the back. In subsequent periods Beckmann often made use of archetypal situations of this kind; the present one may depict a real occurrence. At all events he never forgot it: the old man recurs in later paintings and foreshadows the aged figure emerging from the sea in Beckmann's last triptych, *The Argonauts*.

Another print of 1923 should be mentioned: *The Curtain Rises* (frontispiece), showing, on a mysterious stage, a group composed of a skeleton, a woman mounted on a reptile, a crowned figure and an angel with a huge trumpet. This is a variation on the theme of the world theatre, with symbolic figures as well as objects. The subjective inspiration is lost to view, the element of fable takes over. From this point of view, the modest drawing may be regarded as a prelude to the great triptychs.

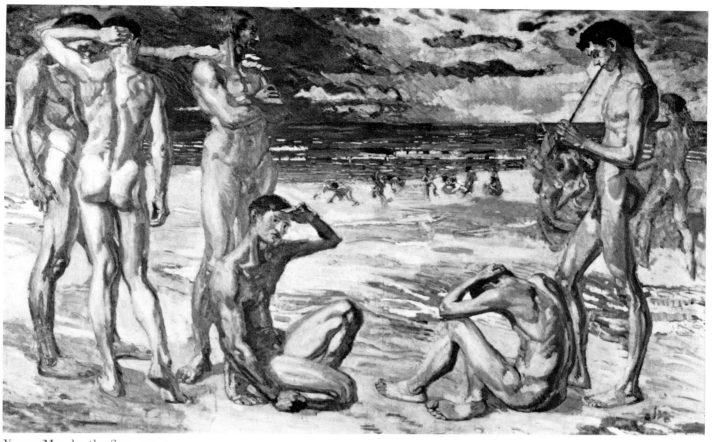

Young Men by the Sea 1905

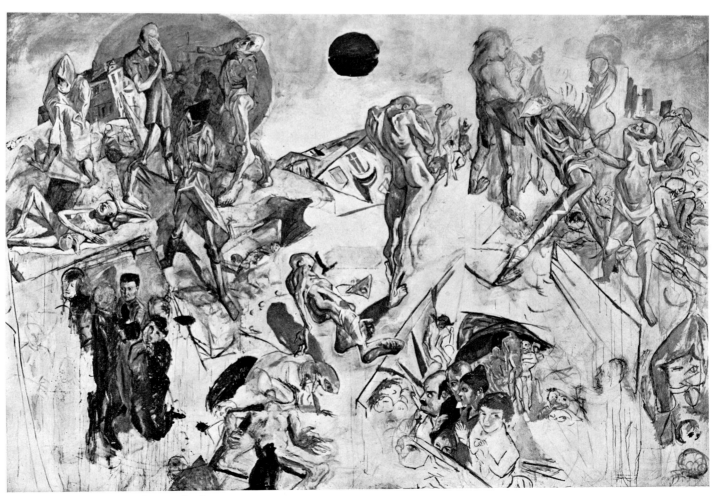

Resurrection (unfinished) 1916-18

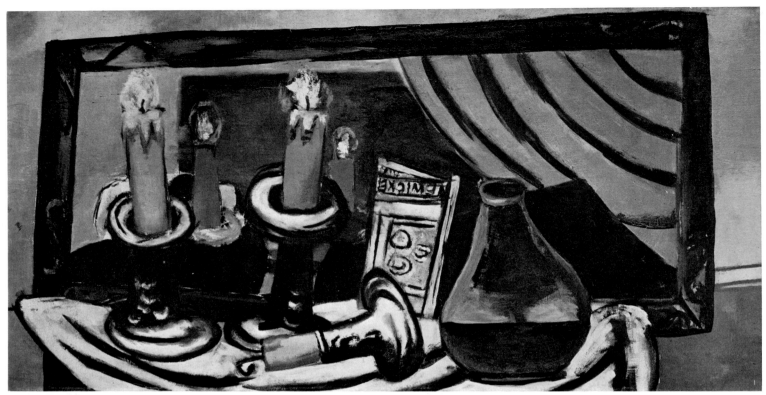

Fallen Candle 1930

Seashore 1935

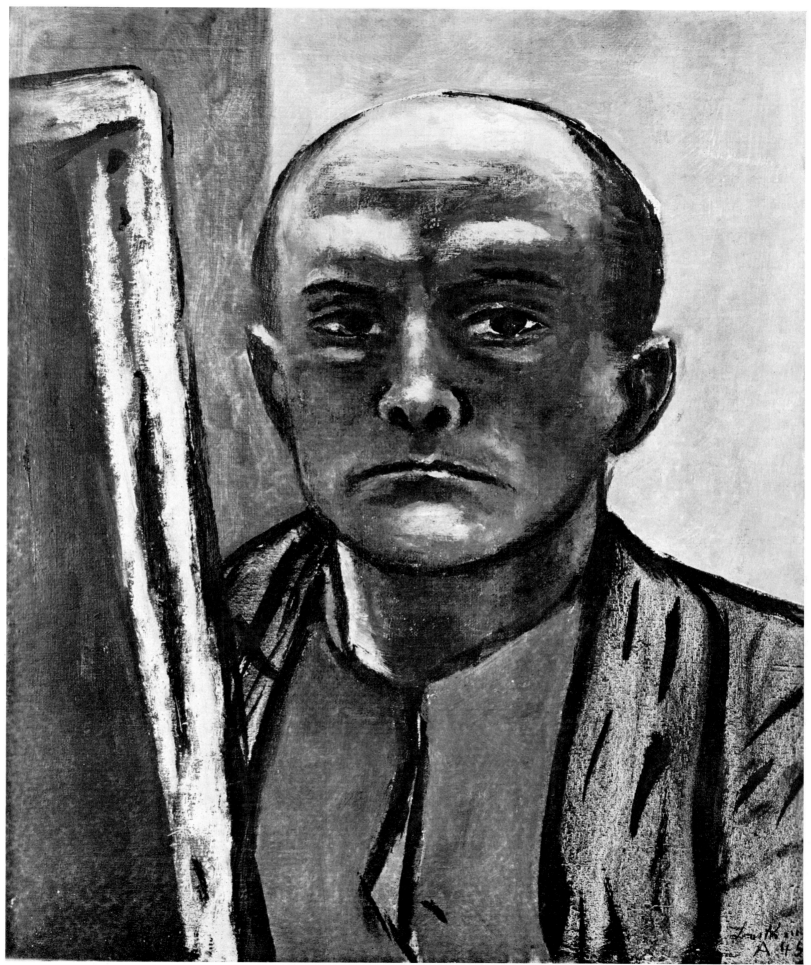

Self-portrait with Easel 1945

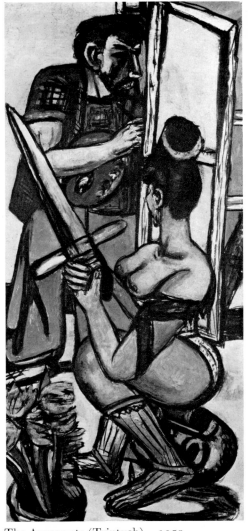
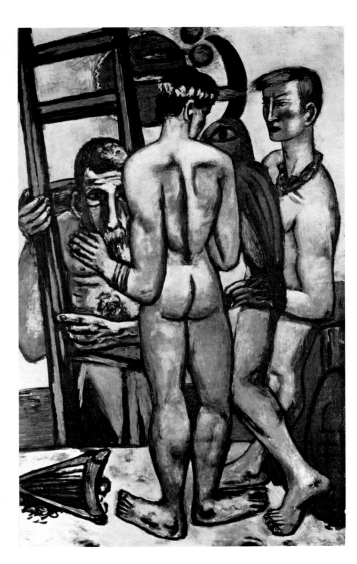
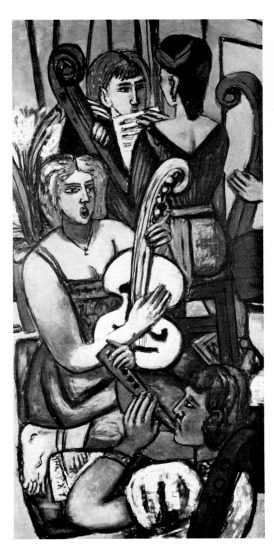

The Argonauts (Triptych) 1950

Pierrette and Clown 1925

The evolution in Beckmann's attitude to life, a gradual process attended by setbacks, was followed in 1925 by two events that endowed him with fresh energy and, for a time at least, self-confidence. In that year he took up a teaching appointment at the Städelsches Kunstinstitut in Frankfurt, and also married for the second time. The first of these events testified to the fact that he had once more achieved recognition as an artist, and it also made specific demands upon him. As a teacher he was at pains to preserve an appearance of detachment from his pupils. The time devoted to lessons was strictly meted out; he was frequently laconic, but this concealed an intense interest and power of concentration. He had an extraordinary gift of empathy, and his influence on students' work proved that he devoted immense though unobtrusive care to the progress of each individual.

A still more important event to the artist was his marriage to Mathilde von Kaulbach ('Quappi'), whose charm has often been described and lives on in his portraits of her (page 63). In the early stages, as was his manner, Beckmann showed reluctance to give unreserved expression to his happiness; such at least is the impression conveyed by the double portraits of 1925. The excess of sensibility has gone, but there is a marked effect of distance and understatement, suggesting a kind of superstitious hide-and-seek: fear of the envious gods or of destroying one's happiness by proclaiming it too freely.

In the *Pierrette and Clown* of 1925 (page 30) Beckmann introduces himself and his wife on to the world stage by means of the roles and costumes of Italian comedy. On this occasion he enhances the mystery by wrapping his own head in a sort of cowl or bandage, a motif which can be traced in his earlier graphic work. His peculiar attitude with both legs upraised is reminiscent of *Carnival*; in that work it suggested defiance and despair, but here it seems more likely that the artist, safe in his disguise, is permitting himself an indecent joke. At the same time the work has more reflective and sombre aspects. Not only the familiar *Vanitas* attributes, but the woman's pose, her face distorted by make-up and the averting gesture of her left hand—all these suggest a sphinx-like, alien quality, or at any rate a magic stylization in keeping with the painter's apotropaic intention. This intention, it is interesting to note, likewise affects the form of the picture. The great achievement of the composition is that despite the intimations of space and plasticity, the whole work is condensed into a 'pictorial formula', as self-evident and self-contained as an ideogram or a playing-card. The grotesquely numerous anatomical 'errors' do not appear as such but as indicating a particular system of reference. Although the material objects are not lost to view and even acquire prominence—for instance, the majestic cello and the sharply illuminated clown's hat—the term 'New Objectivity' seems less and less appropriate as compared with that of 'magic realism'.

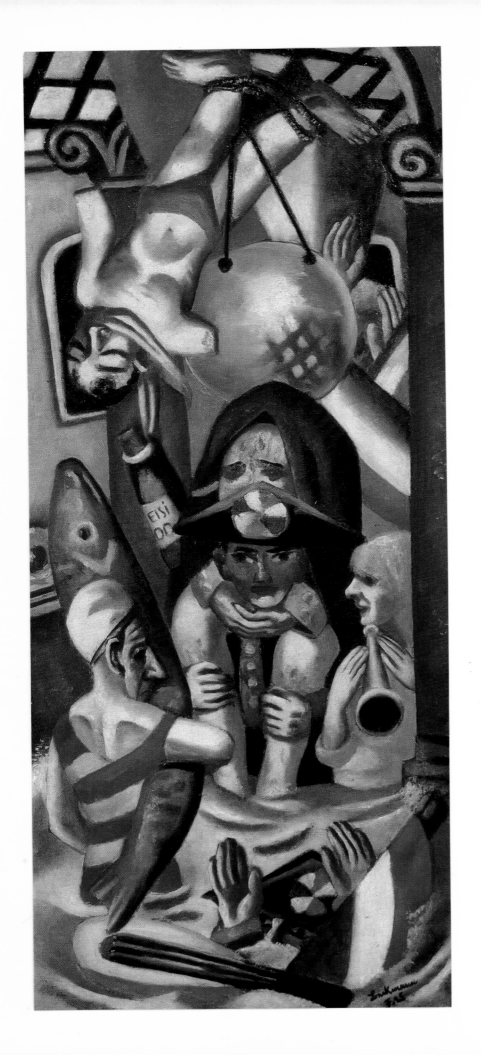

Looking at the colour scheme, we find that Beckmann has largely shaken off the influence of late Gothic panel pictures. His pictures of 1925–6 are distinguished by the adoption of a new manner, particularly as regards the use of white, which looks as if it had been laid on with a very dry brush. It also appears throughout the coloured parts of the picture, either by way of heightening them or in separate touches, not fully blended with the rest. This pervading use of white has led some to speak of 'ice colours'; it is also reminiscent of white chalk. Beckmann often sketched out his paintings beforehand in chalk of different colours, and we may suppose that his new technique was suggested by this practice. Its artistic purpose is another question. One may think in terms of an anti-naturalistic effect or of estrangement, the unreal and artificial, together with associations of cold, though visually we are less reminded of ice and snow than of cosmetics. An important unifying element is that those parts of the picture that are given a special character by the admixture of white form a compositional system of their own. This is perhaps one reason why, despite the differentiation of space, the composition has an almost heraldic impact. Apart from this the palette is a restricted one, consisting mainly of brown, green, grey and blue. There is little red but an imposing purple that contrasts admirably with the artificial 'ice colours', thus pointing the way to new forms of free and effective coloration.

Galleria Umberto 1925

The *Pierrette and Clown* is certainly one of Beckmann's masterpieces, but it does not give a full impression of the growth of the artist's resources in the 1920s. A better idea of these can be gained from another masterpiece, *Galleria Umberto*, also of 1925 (page 38). The title refers to a well-known arcade in the centre of Naples, the nineteenth-century splendour of which is visible in the glass roof and purple columns with golden capitals. The picture seems to me to render most convincingly the curious coloured light that prevails by day in the arcade, with its lively throng of customers. Beckmann visited Naples with his bride in 1925: it is not surprising that he was fascinated by the arcade or, given his temperament, that he combined the impression of bustle and confusion with images from his own fantasy so as to produce a composition imbued with mysterious symbolism. The precise interpretation of the work is a matter for speculation. Some twenty years later, when the Fascist regime came to its miserable end and photographs of the body of Mussolini, hung up by his heels, were on show in Milan, Beckmann himself was surprised to notice that he had introduced into his picture in 1925 a corpse hung up by its feet, with the arms chopped off, and, in the centre of the canvas, a bloodstained head that bears a striking resemblance to Mussolini's, with its domed forehead.

Another curious circumstance is that when painting the picture Beckmann described it as a 'cryptic vision of the future'. Suspended alongside the corpse is a large crystal ball, the age-long appurtenance of the soothsayer, in which vague colours and forms can be descried. The same motif is found in a similar context in the left panel of the triptych *Departure* (page 51), and in 1937 Beckmann portrayed himself with a crystal ball in his hand, in the attitude and with the expression of a man foretelling evil. Whatever we may think of the historical coincidence, it is certain that the painter regarded the work as prophetic from the outset. The flags and uniforms give it a political atmosphere, and the note of doom is evident in the sudden flood by which the *carabiniere* is engulfed. The huge fish and the figures in bathing costume seem to introduce a seaside theme unconnected with the other, but links between them will be apparent in a later picture.

Apart from the singular motif of the flood, we may notice the animated colour-scheme. The intensity and richness of Beckmann's palette in this work may certainly be put down to his experience of Italy. A festive counterpoint is created by the contrast between purple and golden yellow and by the chromatic chord of the Italian tricolour. The 'ice colours' are again in evidence, but seem to be confined to the imaginary elements of the picture: they may be seen in the surface of the water, the crystal ball and the flesh of the ghostly or inconsequent human figures.

The spatial relationships are as unreal as the figures: the planes overlap in a curious way and form a kind of zigzag from front to back. Another strange detail is the way in which the figure with the bloodstained head appears to merge physically with the soldier in the centre. All these features can be traced in some degree to earlier beginnings, but together they produce an effect of novelty and of a sudden breakthrough. As the visionary character of Beckmann's work becomes more pronounced, so does the freedom of composition. He had thus embarked on a course that was to lead him beyond the bounds of 'magic realism'; but his visionary style and the artistry that went with it did not come to full development until the astounding triptychs of the 1930s.

The Boat 1926

A picture painted in 1926, and described by the artist himself as an important work, displays a new variant and a new phase of his 'hermetic' style, especially the trick of making it clear that a painting or drawing has a mystic sense without giving any hint as to what that sense may be. *The Boat* (page 41), originally entitled *Play of Waves*, shows at first glance a company of carefree bathers, presumably at the seaside, who have hired a rowing-boat in which to enjoy

the water and sunshine; a small sailing-vessel approaches on the left. This seems a straightforward reminiscence of Italy, but a second look induces doubt. 'Topless' bathing-costumes were unknown in the twenties, and it is not obvious why the woman in a blue costume has unveiled her breasts. The curious gestures of the two women in the bow evidently have some significance, and their relative position and pregnant relationship to the horizon combine into an expressive configuration. The section of the painting which contains these enigmatic features is also remarkable for its spatial overlapping and the strange juxtaposition of the two boats. The small man in the black cap, half-quaint and half-mysterious, is hidden by the sail with such careful precision as to thrust on us the question of his identity (it is the artist himself). This is also true to some extent of the woman sitting upright, though here we may guess with less difficulty that it is his wife Quappi. Altogether the group nearer the horizon is a puzzling one, and Beckmann takes care that we should be aware of this. The riddle cannot be solved without special knowledge that we are certainly not expected to possess, and we are forced to conclude that he wants us to perceive the mystery but not to solve it. This may be dismissed as a catchpenny procedure, but for Beckmann it is deeper than that. His object is not to allure the public by a promise of interesting disclosures, but to draw attention to the mystery of life by the representation of enigmatic incidents. He himself cannot provide a key to the mystery; he does not believe, except intermittently, that there is one, and he is not concerned to offer us his private speculations. All he sets out to do is to give an impression of what belief in the mystery may entail.

The aspect of mystery does not apply only to the content of the present work, but in some degree to its form also. This is seen not only in the typical motif of concealment—as with the man in the sailing-boat, the face of the woman in the bow and the head of the child beside the man rowing—but in the whole composition, which forms a kind of mystic symbol. Although the task is a much harder one than in the seated group of *Pierrette and Clown*, the painter has succeeded in making an expressive, pregnant figure out of the differentiated complex of the two boats. Their contours and structure both contribute to this effect, and the line of the horizon plays an important part. The picture has a unique and surprising beauty which, I suggest, is due in large measure to this hieroglyphic composition. The way in which the converging lines of the boats' sides are brought to a vertical by the mast, the women's bodies and the rower's back, while the horizon cuts this at a right angle and the oblique lines are repeated at the stern of the rowing-boat—all this is not simply a decorative arrangement of shapes and masses, but represents an endeavour to reduce an intricate complex of delicate relationships to a formula whose basic content remains a mystery.

The colour-scheme makes its own contribution to the enigma. This is observable in the dominance of the artificial 'ice colours', which impart a ghostly effect although the scene is in

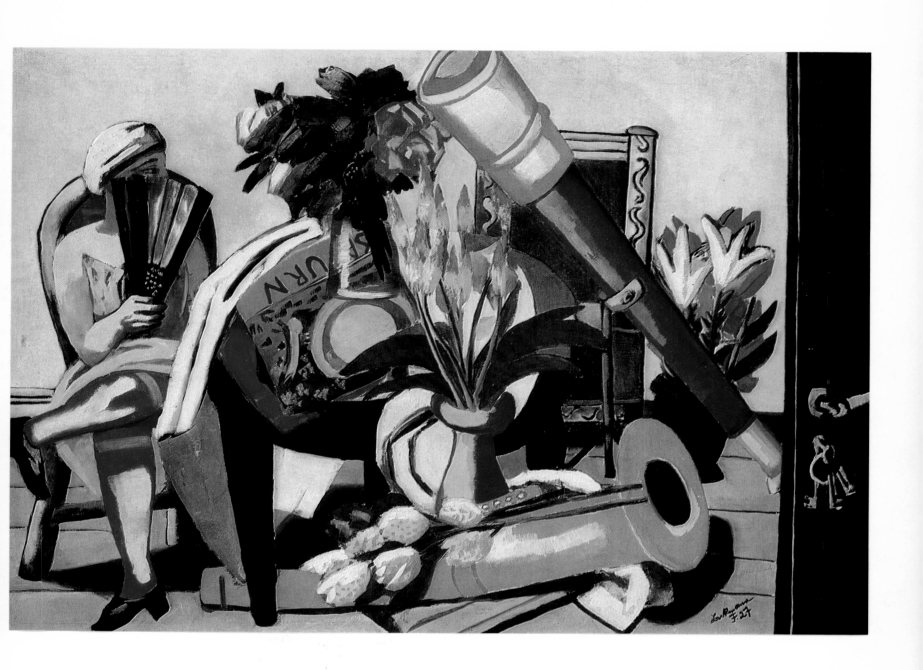

broad daylight, and give prominence to the mysterious oarsman in the centre. The hoary foam blends admirably with the sea-green water. Besides the iridescent white, the picture contains heraldic combinations that we recognize from the *Galleria Umberto:* the red and yellow and the tricolour (although in a different sequence), both repeated twice over. These lively tones hold the composition together in a kind of counterpoint.

Large Still Life with Telescope 1927

One may think of Beckmann's work for the most part in terms of tense compositions involving figures; these are certainly typical of him, but they are not the whole story. His still lifes and landscapes are also important and are surprisingly numerous. He was not wedded to exciting themes, but could make a world out of a few objects. Nothing was insignificant to him, and in his eyes every detail and every chance encounter had a meaning and relevance of its own. Consequently his still lifes, even when apparently based on a chance arrangement of everyday objects, are seldom genuinely 'still', but yield a message once we have come to recognize certain associations. Here again we are back in the world of pictorial tradition. The objects in classical Dutch still lifes often have a specific meaning, as we saw in the case of *Vanitas* paintings. On this basis Beckmann, in his still lifes, could reflect a variety of viewpoints and combine them harmoniously together. His delight in the sensual presence and poetic beauty of objects is no less manifest than his desire to discern hidden metaphors in all that is visible.

His work during the 1920s shows the achievement of a certain balance between these two aspects of his craft. Especially in the latter part of the decade we often feel that it is left to the spectator's choice whether to content himself with the 'delight of the eye' or to allow the speculative elements of the picture to draw him into a search for the multiple meanings of the world of objects. Rather than forcing questions and puzzles upon our notice, Beckmann adopts the attitude of a magician with secret powers, who can make reality appear to us in one guise or another as it suits him.

The *Large Still Life with Telescope* of 1927 (page 43) is no doubt the finest example of this engaging variation in Beckmann's 'hermetic' style. The spectator who comes upon the huge canvas in the Staatsgalerie in Munich is fully occupied, in the first instance, in absorbing the impact of the visual sensations which the artist flings at him with aggressive nonchalance. A strange assemblage of vivid objects meets the eye, set off against the lemon-yellow wall and the light-coloured floorboards. Picturesque, softly shimmering bouquets of flowers appear beside

massive instruments in loud colours. The black table in the centre struggles to maintain itself amid the surrounding blaze; the cloth has slipped off and is replaced by a poster of glowing hue. The blue armchair against the yellow wall is detached from the medley in front but is powerless to subdue it. Only the enigmatic female figure on the left is insulated from the riot of objects. The enormous orange instrument on the floor, panting like a landed fish, gapes towards the open door which, with its obtrusive bunch of keys, projects blackly into the picture from the right.

We do not at once perceive that the title of this work is misleading. Although it is dominated by objects, and even the woman with the fan has the look of a rag doll or a waxen image, it would be nearer the mark to call it an interior rather than a still life. Moreover, we feel that there is more going on than meets the eye, and that some important character is not present. For whom is the stately armchair intended? Who uses the telescope? What is the significance of the open door? The more we surrender to the picture, the more impatient we become: surely something is about to happen? And surely we might now be told who has left the door open, and how soon he or she is likely to return?

In this way the cheerful still life soon turns into a mysterious scene, and the spectator may feel convinced that one or other of its features has a special significance. The massive telescope, for instance, with its purple tube and shining brass fittings, is no ordinary drawing-room object. We may see in it an allusion to science, but it is hard to associate the picture with sober, white-overalled research workers. The blue velvet chair makes us think more of an old-fashioned star-gazer, conversant with the mystic influence of heavenly bodies. It seems quite possible that Beckmann did have astrology in mind: this is confirmed by hints such as the poster on the round table, the title of which is clearly 'SATURN' and which depicts the planet with its ring and a comet sinking towards the horizon.

Comets are traditionally portentous events, and Saturn is associated with all kinds of occult imagery. Old books treat of this at length, and even today this planet's influence is regarded by astrologers as highly complicated and potentially menacing. Moreover, its mysterious, capricious and ominous powers have been believed since the Renaissance to have a special bearing on the processes of creative art. According to the philosopher and occultist Agrippa von Nettesheim, it was a star that enabled artists and magicians to do great things, but involved them in tragic conflicts. It was no light matter to conjure with the powers of Saturn, which could either ruin a man or give him unbounded influence over material things.

Beckmann was himself born under Saturn, and we may safely assume that ideas of this kind were familiar to him. In his work there is something like a Saturnian iconography, in which the dominant though not the only theme is that of coming to grips with alien powers. In the present case, the conflict does not appear too intense: we may think of the work as a self-confident paraphrase, perhaps the set-up for an experiment in which the artist hoped to compel the planet's

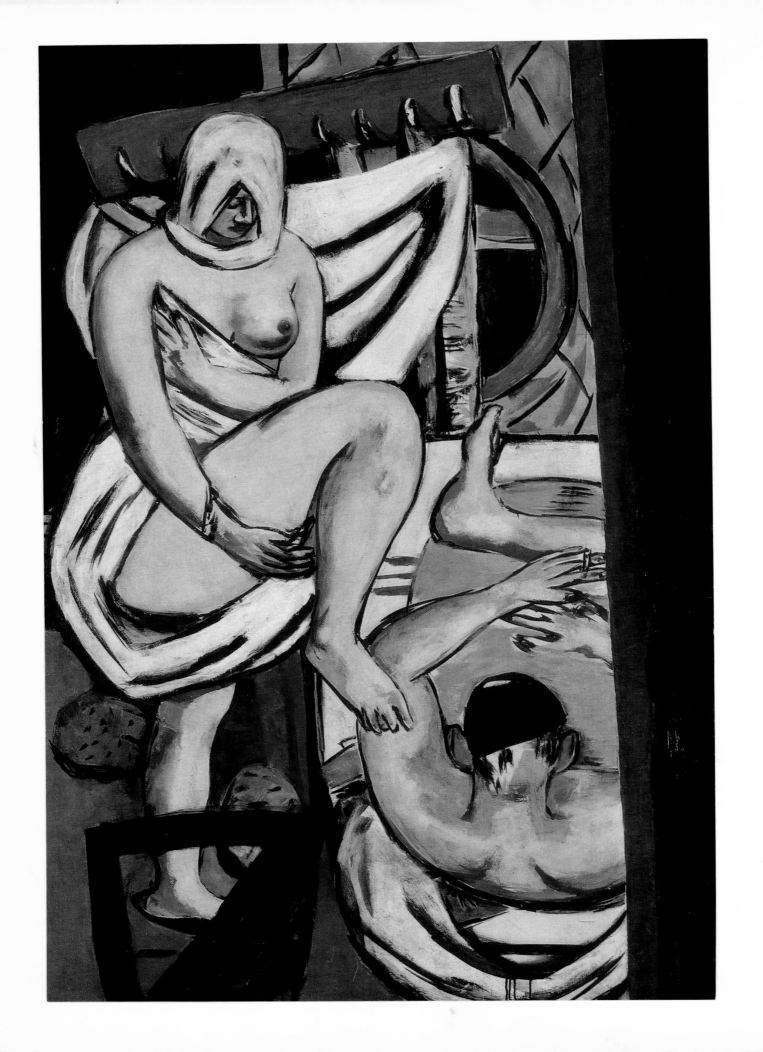

elusive power to serve his purposes and enrich his art. We may interpret in the same way the presence of the large trumpet, which Beckmann often used as a symbol of his eminence as a painter. The function of the woman in the corner is less clear; she may possibly represent the Muse, always bearing in mind that the whole work is an intermingling of seriousness and parody. Its combination of splendour and mystery is in fact best understood if we recall that Beckmann had a taste for out-of-the-way speculation and was also fond of mocking this taste. It seems to me that in this picture he has combined both motifs in a tongue-in-cheek manner, rather as in the *Self-portrait as a Clown* (1921). That work, it may be noted, features a carved armchair of similar design, which may be taken to represent the painter's secret throne.

Another notable aspect of the present painting is that Beckmann's palette has once more undergone a significant change. The strange 'ice colours' have almost disappeared, being only recalled in some degree by the white reflections on the seated woman's legs and shoulders. It is doubtless not an accident that this part of the painting expresses an effect of alienation; the work as a whole, however, is dominated by strong resonant tones and clear contrasts—red and green, blue and yellow, orange and black. The element of colour asserts itself to a surprising degree, so that it seems almost to transcend the object and to exist independently of matter and space. Beckmann in fact went unusually far on this occasion towards what he generally stigmatized as 'decorative' painting. The effect on his style was rather fruitful than otherwise, but clearly his true purpose lay elsewhere.

The Bath 1930

In the late twenties Beckmann's use of colour was increasingly rich, sensitive and full of nuances. His works of this period were highly effective and found ready purchasers. Acknowledging once more the sensual charm of colour, he finally won over those critics who had been offended by his ascetic post-war style. Another element in his success was that he felt reasonably happy as a human being, so that his work ceased for the time being to reflect his basic pessimism. However, this was no longer the case by 1930. His thoughtful picture *Fallen Candle* (page 34) is not only the up-to-date expression of familiar problems: it reflects new aims and a deep refashioning of his style. In the magnificent *Self-portrait with Saxophone*, also of 1930, we see him once more absorbed in brooding. The pictorial intensity which he had developed in the intervening years was not lost but was made to serve the ends of a new monumental style, the logical outcome of the painter's own evolution.

The complexity of the situation is well exemplified in the painting *The Bath* (page 46). Here the colour black makes threatening inroads, and the dark borders suggest uncertainty; but these doubts are swept away by the imposing combination of pictorial freshness and monumental form. Scarcely a trace remains of the steep vertical design that the painter used so often in the twenties. The format is striking but harmoniously proportioned, and the effect of alienation is absent. The conception is a bold and sweeping one: this applies to the contours, the organization of the picture surface and the arrangement in depth.

The correlation between surface and perspective is always instructive; in this case the painter has loosened it in one way and at the same time given it a fresh dynamism by the use of separate picture planes. The foreground is indicated with great simplicity, by a chair-back on the left and an oblique strip on the right, pitch-black and edged in brown, which cuts into the picture with telling effect: the spectator feels that he is close up to it and is looking past it at the main scene. At the back of the picture and parallel to the foreground is a plane consisting of a green patch of wall behind the bathtub, a mirror and a towel-holder. The left-hand portion of the rear wall is ingeniously coloured black, forming a diagonal relationship with the strip in the right foreground and thus avoiding the effect of being closed in. One vaguely imagines a shadowy area extending further back on the left for an indefinite distance; this impression is contradicted by the towel-holder affixed to the wall, but it persists none the less and provides a foil to the principal figure of the woman standing beside the bath.

The 'action' of the picture lies between the front and the rear planes. Beckmann is seen in the bath wearing a black cap and holding a cigarette, while his wife stands and dries herself. The achievement of the picture is to combine a perfect plane composition with the expressive use of depth. There is a strong perspectival effect on the right: Beckmann's figure is a massive one and the bath is too short for him to stretch out, but his head appears close to us and his foot some way off, so that we get a sufficient notion of the dimensions of the tub and bathroom. At the same time we get an impression of space on the left, since the right-hand side of the picture gives us an idea of what the distance must be between the chair-back and the woman's leg.

It is noteworthy that the figure in the bath is seen from above, while the woman's body is perceived somewhat from below. The effect of this device is that elements which are in perspective, such as the expanse of water in the bath, appear to be part of the surface plane. The position is more complicated on the left of the picture, where the top view and the view from below are, so to speak, interlocked with each other. We seem to be looking down into the folds of the huge towel, but upwards at the woman's massive thigh, and the sense of looking up is enhanced by her curiously small head. One cannot exactly say that the woman's compact figure is elongated by this means, but Beckmann does create an impression of this kind, accentuated by the spread of the towel behind her back. Here again, everything is done to make

spatial relationships contribute to the surface effect. This leads to a dynamic presentation of figures, indicating clearly what the artist has in mind. Depth and volume are not the only important elements, but must play their part with others. The composition is seen as a vibrant pattern of strong lines and colour patches. The alterations of viewpoint and the opposition of sweeping curves produce a surface tension to match and express the vitality of the figures.

In this context, colour takes on a unique energy over and above its function of denoting objects, let alone that of mere decoration. The magnificent harmony of green, brown, yellowish-white and black plays a basic part in distributing accents and tonal effects; but its main achievement is to impart a sensual vigour to the composition as a whole—not merely the dazzling body of the woman, the green of the bath-water or the texture of the sponge. Even the black has something colourful and tender about it, perhaps as the result of a kind of transference: the impulse of accentuated feeling which we receive from such vivid areas as that of the woman's flesh is applied to elements which in themselves have a neutral or opposite effect. In this way the dark background and foreground suddenly come to life; the mirror and the chair-back assume a physiognomy and activity of their own. An analysis of this sort is of course inadequate and merely auxiliary. But I would add the rider that, to produce such a painting, gifted brush-work is not enough; it is above all an example of masterly composition.

Around 1930 Beckmann spent several months of each year in Paris, where he hired a permanent studio. Apart from general effects of the Paris atmosphere, it is not easy to discern any particular influence resulting from his stay there. He was not interested in the encounter with French painting as such, but rather with asserting his own individuality as an artist against the fashions of the day. Although the Musée d'Art Moderne in due course purchased two of his works, one may say that his independent attitude has not, to this day, won him any large measure of recognition in France; but it was certainly of value to him at the time. His work was by no means inferior to that of the contemporary École de Paris, and he made no sacrifice of his principles, including regard for the subject matter of his paintings and concentration on the intensity of spatial composition.

His work during the next few years shows that he became more rather than less single-minded in this respect. It also shows him inextricably involved in the tragic predicament of his country's destiny—*das deutsche Schicksal*, a phrase with fatalistic yet pretentious overtones. For a man in Beckmann's position in the thirties, 'destiny' was apt to take the form of yielding to force. As many indications show, he took the line of regarding political conditions and events as something external, which one could overcome by retreating from it into one's own mind. It would be wrong, however, to consider him as a mere fugitive idealist. In his artistic creation he spoke out sharply against the signs of the times; not, to be sure, in a way that could be understood at once, but at least more directly than was possible to painters of 'pure form'.

Departure 1932-3

In 1932 Beckmann was offered an appointment in Munich and was inclined to take it up, but he was persuaded to stay in Frankfurt until 1933. Soon after the Nazis came to power in that year it was made clear to him that he was not wanted: he had to give up teaching at the Städelsches Kunstinstitut, and there was no chance of a similar job anywhere in Germany. He moved to Berlin, hoping to go on working unobtrusively in the capital until such time as the spectre of Nazism disappeared or was exorcized. Again, this does not mean that he underrated its power for evil; we shall see in a moment how clearly he beheld the vision of a bloodthirsty tyranny. His mistake lay rather in supposing that the zenith of aberration must soon be reached, and that a purifying catastrophe would follow.

These hopes and perceptions may be studied in his first triptych, begun in 1932 and finished in the main by the end of 1933 (page 51). Its title, *Departure*, clearly does not relate solely to his leaving Frankfurt. All interpreters of this remarkable work have emphasized the aspects of mystery and fable. The choice of the triptych form, as of a late Gothic winged altarpiece, is significant in itself and alerts us to a singular depth of meaning.

We may best approach it by recalling the *Galleria Umberto* of seven years earlier (page 38), with its vision of the atrocities and the bloody end of Fascism. The theme which was then condensed into a single picture is here expressed in a didactic sequence, as in a mystery play, ending on a note of consolation. Turning to the individual motifs repeated from the *Galleria Umberto*, we find, firstly, the crystal ball in the bottom right corner of the left panel of the triptych. A woman with bound wrists is bending over it; a newspaper lies in front of her, and we may suppose that it is the report of some specific event that prompts her anguished reading of the future. The theme of binding and mutilation is prominent in both wings of the triptych, and on the left we find again the gruesome motif of the chopped-off hands. The quieter motif of the fish is also repeated: it occupies a key position in the centre of the triptych, and also in the right panel. For reasons that can be well understood, the later work contains no direct allusions in the shape of flags or recognizable uniforms.

Lastly, there is the water motif. In 1925, symbolizing the approaching end of the regime, it seeps into the covered arcade from below like the beginnings of a deluge, sweeping away a soldier and a flag as its first victims. In the triptych, water plays a different role: the serene blue of the central panel, bounded only by the horizon, is a symbol of escape and freedom. None the less there is a direct connection, bound up with the mythological theme of a deluge. This theme was the subject, in 1908, of one of the most impressive works of Beckmann's youth. It fascinated him from then on, both as a painter and as a reader, and we know that in the early thirties

he was taking an especial interest in the various counterparts of the Biblical story: in particular the Babylonian legend and the Hindu one in which Vishnu, in the shape of a fish, gives warning to the elect human beings who are to escape the flood. Beckmann was closely familiar with all these tales, as we know from annotations in his books. We cannot discuss in detail here the interpretation of the triptych, but with regard to the central panel it may be pointed out that in addition to the divine fish, some Hindu sources refer to a mysterious hero and his saintly wife, while in the Babylonian myth it is a king who plays the decisive part.

A more interesting question is how Beckmann intended to relate the symbolism of the deluge to the events of his time. Here the key notion, common to all legends of the flood, is that of the 'purifying catastrophe' to which we have alluded. While the Biblical story lays weight on divine punishment, the other legends stress the aspect of renewal and rebirth. When chaos and horror have reached their height, the gods set an end to suffering and start the world afresh. Corruption is engulfed by the waves; a small group of elect survivors sets out in a boat with the task of creating a new life.

Thus the triptych shows us three stages of the drama. On the left and right we see mankind in a desperate situation, with violence and horror triumphant; hope is dead, life has become a torment. The second act begins with the breaking of the deluge, a moment caught in the *Galleria Umberto*, while in the triptych we see the action at its climax: the survivors in their boat, the infinite expanse of waters in the brightness of a new dawn. The royal figure solemnly inaugurates life upon earth by releasing a netload of small fish into the water, while the mighty fish in the boat represents Vishnu and the renewal of vital forces.

We may wonder if all this did not have an even wider meaning for Beckmann than the allegory of hope at a time of political despair. In the last resort, as many of his remarks indicate, he probably intended the work to have a religious or mystical significance. At its deepest level, the legend of the flood stands for the consummation of the world, the final release of the spirit from the illusions of life and its return to the realm of freedom. This may help us to understand the magical intensity of the horizon-line in the centre panel. But in contemplating the work we should be aware simultaneously of all the dimensions of meaning as they overlap, intensify and penetrate one another: the historical predicament and the symbolic transformation, the mythological concept and the mystical apotheosis of freedom.

So much for the subject matter. What is new in it is not only the combination of meanings at different levels, but the fact that the painter's subjective vision is expressed in terms of an existing myth. Instead of proceeding by means of magical suggestion, Beckmann seeks to achieve his effect by evoking a theme of universal validity, while treating it with a brilliance of composition that is all his own.

This we may now attempt to analyse. In the first place, it is clear that the work as a whole gains much of its effect from contrast. The side panels, with their fragmentary images and lines running counter to one another, give an impression of chaos, while the heraldic composition of the centre is enhanced by the painter's new, monumental style of figure drawing. The wings depict movement in a state of frustration, the centre is calm and concentrated. The claustrophobic effect of the sides is offset by the majesty of the central horizon: the world of chaos offers no escape, but the survivors have an infinite world before them.

The horizon strikes the eye at first glance as the dominant motif of the triptych, but its power also grows on us the longer we look. To explain this fully would require a detailed analysis of the picture space and the group of figures. Here we will only observe that the painter again resorts to the combination of a view from above and one from below; he also juggles ingeniously with the phenomena of mass and distance and with a kind of colour perspective involving the interaction of red, yellow and blue. When all this is said, there remains a kernel of mystery in the whole work that cannot be explained in terms of composition and calculation. We feel, especially in the centre panel, an intensity which surpasses the normal and which it is beyond the spectator's powers to attempt to fathom.

Seashore 1935

The *Departure* triptych expresses side by side the extremes of distress and hope; their contrast gives the work a kind of stability and suggests the 'dialectic', as we should call it today, which has in all ages enabled men to rise above evil by discerning in it a promise of redemption. In Beckmann's mind, however, there was no lasting sense of unquenchable hope. His first piece of sculpture, a tremendous work executed in 1934, bore the significant title *Man in the Dark*. From 1933 onwards his mood was often one of despair; the pessimism of his philosophy took on new dimensions, and many of his finest paintings have a bitter taste. If we compare the centre panel of the triptych with a well-known picture of 1935, the *Seashore* (page 34), the contrast of mood is unmistakable; it can be seen especially in the treatment of the horizon.

The spectator is struck, first of all, by the oblong shape and the curious elongation of forms. The sea is dark blue, the sky grey; the beach gleams with a sickly light. The horizon has an unwelcoming look, the boat is abandoned on the shore; the sun shines dully, obscured by clouds of peculiar shape. Of course a mere landscape cannot be directly compared with a visionary scene such as that in the *Departure*, but by confronting the two works we may see how Beckmann

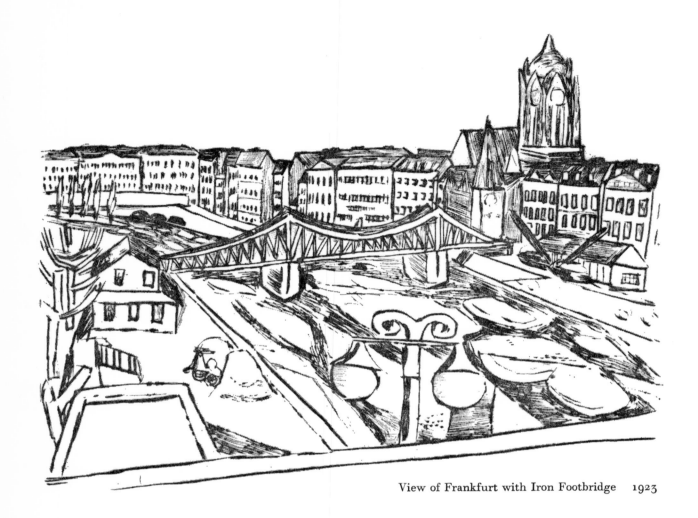

View of Frankfurt with Iron Footbridge 1923

endowed his pictures of nature with thematic significance. The *Seashore* is certainly based on a visual experience, but no less certainly it has a subjective content: observation and interior vision are blended into a composition that may again be termed symbolic. We do not know precisely how or why this happened. Beckmann, of course, had no need to make his landscapes more impressive by filling them with emotional content, but perhaps he was so constituted as to experience everything in symbolic terms. Far from seeking to improve on nature with inventions of his own, he was probably concerned to transmute his formidable visions and experiences into terms of pure art, clarifying them by the optical evidence and thus attaining the sobriety which he regarded as a first condition of artistic achievement.

'Objectivity of the inner vision'—the slogan of 1917 was still valid and signified a duality in Beckmann's work, requiring a balance of extreme delicacy between the subjective and the objective. The two aspects are inseparable and can be kept in harmony only by the constant

exercise of artistic intuition and judgement. Looking at the mournful picture of the seashore with its curiously sloping horizon, we feel as though the artist were summoning Nature to reveal some riddle of existence, yet it is remarkable how free the work is from any touch of subjectivity or introspection. The scene is treated with a sort of awe and is depicted in a reserved, almost hesitant manner, as though Beckmann feared to become too closely involved. Internal and external reality were to him limiting values, and the artist's role was to mediate between them by his portrayal of the visual world.

The economy with which he does so in this picture is extraordinary. The contours are few, and the casual impression of dull uniformity is enhanced by the fact that many of the lines are more or less parallel. Similarly the range of colour is limited and confined mainly to half-tones, the tension being further reduced by the care with which they are modulated. All this reserve is necessary to lay bare the essential mood of the picture, which is one of nuances and extreme sensitivity. This is shown in the tenderness of the colouring, the subtle harmony of greys, blues and yellows which complement each other in the sky and blend in the shimmering sand of the foreground. The same sensitivity appears in the composition; it is present to an astonishing degree in that part of the work which on the surface is more or less commonplace, namely the contours and the graphic aspect in general.

We know that Beckmann was a master of clear delineation, and the precision of his outlines is a matter for constant amazement. Yet in this painting it looks as if he had done his utmost to devise a hesitant, uncertain, even careless manner of drawing. This is especially true of the vaguely sketched pool in the foreground. The patch of shadow with its sharp outline near the lower edge of the picture has an unfinished look; so does the hillock with its different shades of green; the horizon itself looks awkward and carelessly drawn, and the clouds in front of the sun, impressive as they are, have an air of being hastily sketched in. We accept all this as a matter of course: it is part of the picture's 'expression', but the painter has clearly imposed on himself for the occasion a discipline of understatement. Everything is meant to look accidental, uncontrolled, unintentional. Almost without our perceiving it, Beckmann has introduced a note of dilettantism into his style. This is in fact an ideal way to conceal his inner involvement, to damp down the sentimental aspect and exclude any thought of romantic melancholy. If he had painted the scene a fraction more fluently or a shade more explicitly, its sensitive balance would have been destroyed. The hint of disinterest, boredom and indifference enables him to keep sentiment at bay. This curious attitude of self-denial calls for a new and special type of concentration, avoiding any suggestion that might mislead by its familiarity and turn the experience into a cliché. The sketchy, hesitant style also helps in no small degree to create the ambivalence between surface and perspective whereby the picture develops its own private sphere of reality. In his own fashion, Beckmann is here a disciple of Cézanne; it is not accidental that he frequent-

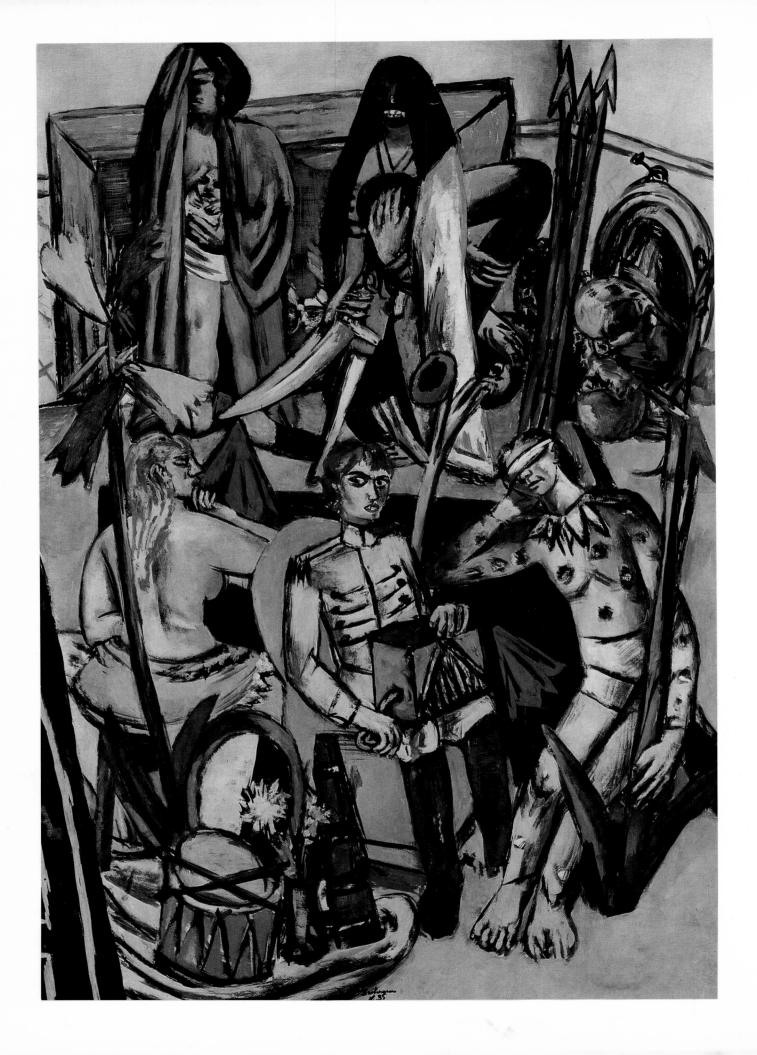

ly quoted the latter in his writings about art, taking him as the supreme guide in regard to the modern problem *par excellence* of the relationship between the picture surface and the dimension of depth.

Despite the complication of its psychological and artistic background, the painting itself is relatively simple. With all its delicacy and the fineness of its shades, it is easy to apprehend either as a naïve work or as a piece of subtle artistry. Everything in it appears right, simple and unpretentious. The initial impulse, and the complicated process to which it may have given rise, are resolved into a work of pure art. As such it may affect the spectator in terms either of emotion or of critical reflection, since both are equally present in its form.

The Organ-grinder 1935

Beckmann painted several hundred landscapes, some of which stand out as unique in the present century. As with his still lifes, he was able to express in modern terms a great tradition whose future seemed to be in doubt. He himself did not regard these genres as of the first importance: as the political horizon darkened, he felt more and more that painting should not restrict itself to what was immediately visible.

In the middle thirties he reverted to the arduous task of treating philosophical problems by means of symbolic works. As in the past he made use of 'hermetic' elements, and the notion of a secret meaning took on a new dimension. Instead of confining himself to a private universe, he gives the impression of seeking increasingly to address himself to a circle of neophytes or initiates.

In practical terms, this was of course illusory. Beckmann never possessed an elect circle of disciples, and the idea of having one would probably have excited his amusement or sarcasm. None the less he evidently supposed that his pictures might convey a secret intimation to unknown persons who, as he once put it, 'carried in themselves, whether consciously or not, the same metaphysical code'. In this sense it seems to me useful and proper to regard such works as the triptych *Temptation*, the later triptych *The Argonauts* or the *Organ-grinder* of 1935 (page 56) as 'initiatory' paintings designed to acquaint the spectator with a secret world of truth, generally a bitter one.

The *Organ-grinder* is also known by the title *Song of Life*, chosen by its owner, Lilly von Schnitzler. This may help the viewer to overcome his bewilderment on first acquaintance with its medley of symbolic figures. Much as we may admire the intoxicating brilliance and efferve-

scence of the painting, it is clear at the same time that Beckmann has pulled out all the stops of his imagination, presenting the creatures of his mind to the spectator with ruthless clarity. The form is, as it were, choreographic, without regard to the laws of nature: plants start up through the floor, lances bristle among mirrors and picture-frames, and the figures in their puzzling costumes are disposed in unrelated planes.

The whole scene might be regarded as an allegory based on the idea of a stage performance— the theatre, as in Beckmann's earlier work, being that of the world. The performance, disturbing in itself, is accompanied by the macabre notes of the hurdy-gurdy. Instead of a jester, the musician stares at us challengingly from the centre of the picture, as if he were saying 'You are in the play as well', or, perhaps, 'Beware, the joke is at your expense.'

What exactly is taking place? The allegory is difficult to unravel without a key, since, like the *Departure*, it is based on a mythological theme, expressed particularly by the two female figures at the top. The half-veiled woman on the left is holding a new-born or unborn child; the other holds a bloody sword and her veil is partly black, partly white with bloodstains. Her pitch-black face and gleaming white teeth show her to be Kali, the Hindu goddess of death. Kali—the name itself means 'black'—is usually seen with a sword in one hand and a freshly severed head in the other, and she may also have one foot on a victim's head. The two women are an allegory of birth and death, but they constitute different aspects of one and the same deity. Kali is the goddess of death, but also of motherhood and the life-force: she consumes what she herself has brought into the world. Her two aspects together signify a disillusioned view of the life-cycle, in which man is born only to die.

We cannot be sure what the hurdy-gurdy means, but the suggestion of hackneyed repetition is clear enough. The buxom blonde on the left may be taken to represent unthinking sensuality, while the blindfolded youth in the blue harlequin's costume on the right may signify dreamy hopes and uncritical illusions. As for the organ-grinder himself, we may wonder why Beckmann has made him so young and has put him into a hussar's uniform. The suggestion of militarism in the pale yellowish-green tunic is taken up by the still-life motif in the foreground, a red side-drum with two crossed black drumsticks lying on it.

Are we to think of the organ-grinder as a cadet or a youthful ensign? It would indeed be strange if the painter had not included some reference to the lunacy of war in his remorseless tract on the subject of birth and death, sensuality and annihilation. The overwhelming power of death had appeared to him in all its horror in the trenches of the First World War. When he painted the organ-grinder he may have had in mind the volunteers of 1914 whom he saw dying wretchedly, a few months later, in the field hospitals of Flanders. But the delicate face of the boy in uniform, overshadowed by the goddess of blood and death, is probably meant to suggest the future as well as the past. In Berlin in 1935 it was not hard to predict that more and

more uniforms would be seen in Germany. The Hitler Youth marched the streets to the sound of drums like this one, little imagining whither their march would lead. Beckmann for his part saw the end clearly enough, and it may have been the premonition of a new war that inspired the sinister allegory of the 'song of life'.

Dream of Monte Carlo 1939-43

Beckmann left Germany for good in the summer of 1937, immediately after the fanatical speech in which Hitler declared relentless war on all artists who did not submit to Nazism. Many of his chief works figured in the notorious exhibition of 'Degenerate Art', and he clearly had no choice but to leave the country. For a painter who had kept aloof from the international art world and was as yet little known abroad, this meant some uncertainty, but Beckmann nevertheless felt as though he had been released from an evil spell. For the next two or three years he lived in Paris and Amsterdam. After the war broke out he received an invitation to the United States; he accepted, but before he could get an exit visa the German troops invaded Holland and he was cut off by their rapid advance in northern France. He continued to live and ply his art in a former tobacco storeroom at 85 Rokin, in the old quarter of Amsterdam. In conditions of discomfort and often of great hardship he produced a large quantity of admirable work, his mature style developing in ever-new variations.

We may examine this style in his *Dream of Monte Carlo* (page 61), a painting begun in 1939 and finished in 1943. Beckmann had visited his beloved Riviera in the spring of 1939, and presumably it was then that he formed the idea for the picture. It is another question whether its uncanny visionary quality was part of the original plan; this is not impossible, but the style of the finished work is that of about 1943, and it seems rather likely that the intensity of the theme is the product of retrospect and of the war years. The luxurious surroundings of the casino are transformed by the artist's vision into a labyrinth of hopeless passion and a scene of explosive violence. The elegant mask of high society is a screen for naked brutality. Beckmann shows, in the manner of a final tableau, how unbridled greed conjures up the demons of destruction.

Before analysing the scene in detail we may pause to consider its intensity of feeling and curious emotional tone. This involves basic artistic questions which must be discussed if we are to understand Beckmann's new style and his manner of work during the forties. The first point that strikes the eye is the increase in painterly effect and general artistic energy—an extraordinary phenomenon considering Beckmann's conditions of work during the occupation. Cut

off from most of his friends, with no possibility of exchanging ideas or gauging the effect of his work, he had no means of making progress except by a kind of dialogue with himself. We know from his diary what a tremendous, convulsive effort of will this sometimes entailed. Some have regarded the heightened emotionality of his wartime pictures as a return to Expressionism; but it is easy to show that in his mature years Beckmann always used expressive stylistic devices with a particular intent and not simply as an outlet to his feelings. The vehemence and spontaneity of the picture is the result not merely of an irresistible outpouring of genius, but of discipline.

During the period of his fullest development Beckmann's manner of work involved continuous repainting and frequent modification of the theme of his pictures. Painting in this fashion is a continuous struggle, and the excitement of the final version reflects the violence of the battle which the artist was in constant fear of losing. There are many signs in it that he changed the composition several times; it would also appear that he relied on the overlapping of successive concepts for artistic effect, both from a formal point of view and from that of the irrational, alien atmosphere of the work. For example, it is probably because of a change of mind that the end of the table is repeated in a ghostly way behind the croupier on his haunches on the right, or that the opposite end of the same table merges with the gamester's body. Both these effects are almost more sinister than the two masked figures advancing with their bombs.

We may wonder how, as Beckmann worked in this way, he was able to preserve the freshness and immediacy of the paintwork. One would expect him to use overpainting for his afterthoughts, and indeed he resorted to it more often during his mature period. But in the important areas where vividness and spontaneity were required, he always began afresh, several times if necessary, carefully removing the existing layer and preparing the canvas for a new one. Since this involved waiting, it suited his method of work to have several pictures on the stocks and to move from one to the other. We may follow in his diary how this was accomplished and with what disciplined concentration he turned to each successive task.

In parts of the present work, such as the marble pillar on the left, we can see that overpainting is fully admitted and forms part of the artistic design. In places of concentrated expression we are always aware of the priming even where it is overlaid by successive layers with an effect of glazing. Thus the impression of spontaneity is not due merely to immediacy of painting but to the artist's deliberate cultivation of a sketch-like effect, which he achieves, for example, by giving rough outlines to each application of paint. If we examine the work in detail we find repeatedly that Beckmann has used this trick of feigned improvisation, introducing accents with such precision that they appear fortuitous. This can be seen in a fascinating manner in the faces of the two men in dinner-jackets, or the way in which light and shade are indicated on the green table-tops by apparently negligent streaky lines. We have here, in fact, a highly sensitive

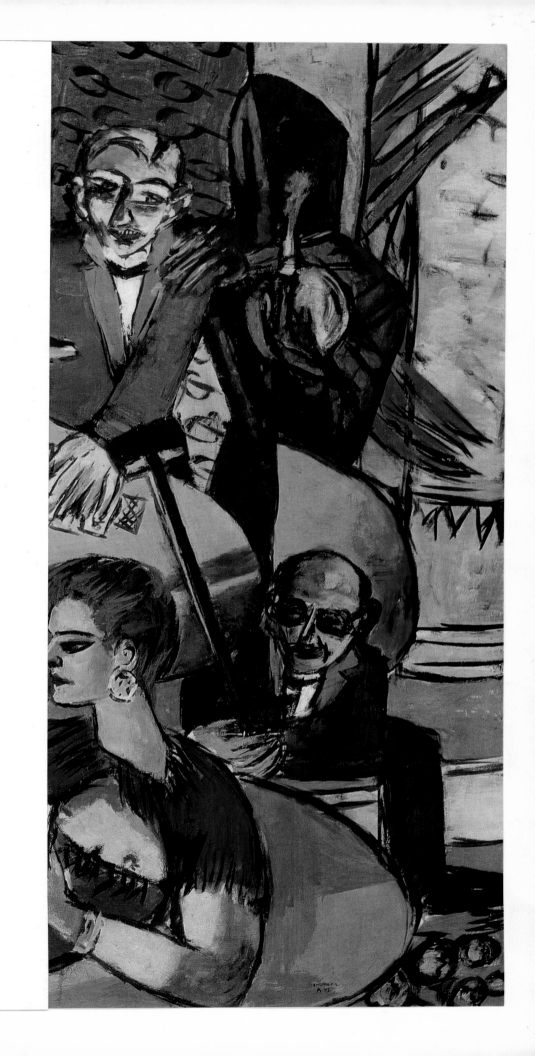

form of pseudo-dilettantism, such as we already noticed in the *Seashore* of 1935 (page 34). This device, which Beckmann raised to a system in the present work, was of course not his invention. It belonged to the repertoire of Impressionism and was much used by modern artists, first by Cézanne and later by Picasso. It is not free from risk. Deception requires constant presence of mind; if it degenerates into a routine it becomes absurd. The would-be illusionist must react to every situation in a fresh, individual way and without the appearance of premeditation. This is why only great masters succeed in this technique, but also why they are much given to it. Among other things it is an excellent way of keeping one's virtuosity under control and avoiding the dangers of excessive facility.

One may even claim that sham dilettantism is one way of satisfying the romantic demand for spontaneity. If an artist has, so to speak, to jump over his own shadow at every turn, the effect is that every stroke becomes an act of daring; nervous tension is constantly renewed, and so is the necessity of a fresh look at the object. This little-observed point helps to reveal an important aspect of Beckmann's method, or at all events to explain the contrast in many parts of the picture between supreme ability and apparent clumsiness. It may also be remarked that Beckmann's pseudo-dilettantism expresses itself differently, although with the same means, from one work to another, and that even within the same work there are nuances to be distinguished. If we look at the hands of the different characters in the *Dream of Monte Carlo*, we find that they are all 'daubed' in a shapeless kind of way but that in each case they are appropriate to the individual and to the action being performed.

The device of primitivism is perhaps at its most effective when it is used to confer life uncannily on material objects, such as the tables and swords in our picture. The rough-and-ready outlines, as if they had escaped from the artist's control, give the impression that these inanimate things are endowed with a mysterious, preternatural power. This effect is intensified in other ways: the green of the tables has a hypnotic effect, and the crude arrogance of the upraised swords is enhanced by the puppet-like appearance of their owners. In such a case it is clear that Beckmann, with his singular gift for characterization, is presenting us with a symbolic picture: greed, aggression and mania have supplanted human agency, while people and things, machinery and freewill, are inextricably and fatally blended.

All these events take place, with seeming matter-of-factness, in a bewildering dreamlike atmosphere of extreme tension. This is created partly by the colour scheme, in particular the opposition of reds and greens whereby the gaming tables are also brought into prominence. The different reds of the wall and floor seem to press forward, while the green shapes float like islands in the centre. It is not by accident that the eye-catching woman on the table in front lends a particular accent to the contrast of red and green. The russet fur round her neck clashes with the red of the carpet, while her flame-like head of hair stands out sharply against the

Portrait of Quappi 1940 and 1942

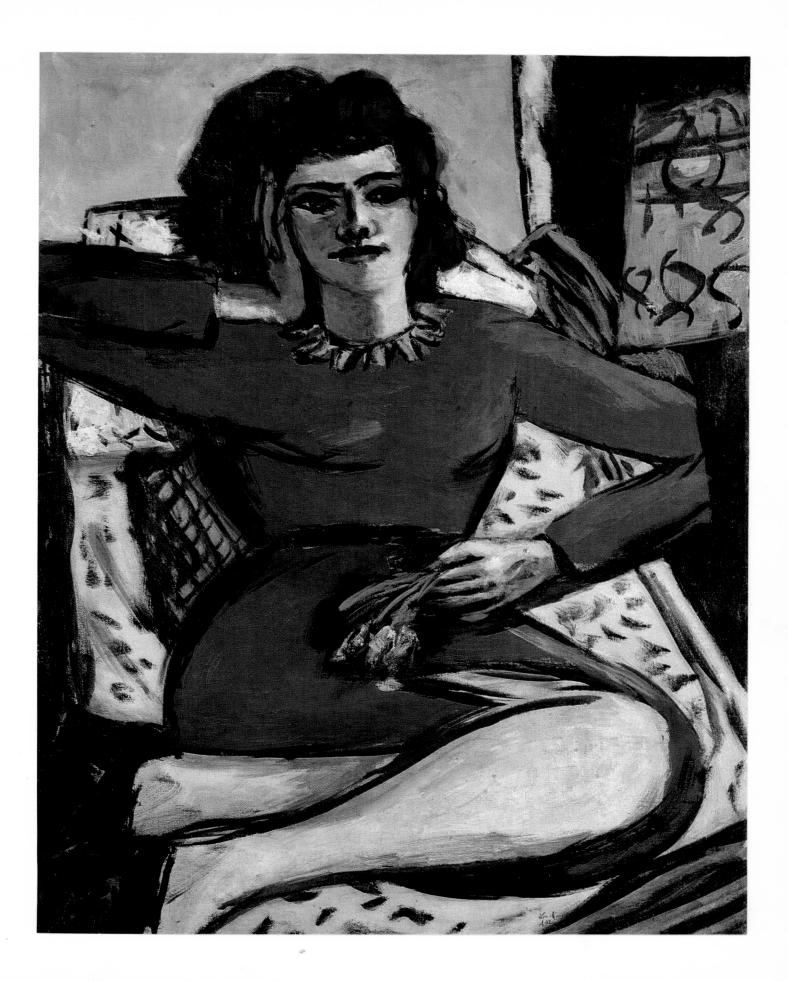

table beyond. All these tensions are not merely abstract: Beckmann combines them decoratively into a colourful yet cryptic portrayal of his characters and their surroundings. The atmosphere of the latter is enhanced by the striking and sumptuous combination of blue evening clothes and golden frames, tropical plants and rose-pink marble columns.

The most impressive effect of atmosphere, however, is obtained not by grandeur but by a relatively subdued gradation of green tones, namely in the rendering of lamplight on the tables. Although the whole room seems to be brightly illuminated, and despite its splendour, the effect of light on the green baize is to recall vividly the unmistakable, concentrated atmosphere of a half-lit gaming room. This may be why we instinctively feel the scene to be one of silence. Dream scenes, of course, are silent anyway, and here we seem to feel simultaneously the moment of suspense as a decisive card is played and the intolerable speechless tension that afflicts us in a nightmare.

Whether the scene depicts an actual dream or whether Beckmann chose to give it this quality is of little importance. What we are concerned with is its visionary impact and the question of the painter's meaning, to which we now turn. As usual, this is not too easy to unravel. The subject is not exactly mysterious, but it is so complex that many aspects have to be kept in view. Consider, for example, the woman half-lying on the table in the foreground— an elegant figure holding what we may suppose to be a trump card, a black ace of hearts. We may also imagine that the men in the room covet this card and are determined to acquire it by force or fraud. But what does it really signify? Clearly a heart of the wrong colour, seen upside down, may betoken many things: it may be an omen of love or death, and the woman may well be a *femme fatale*. Again, the picture links the pursuit of wealth with the idea of fascination by an idol, in this case the enticing female who is looked on as an object or a piece of property. Both these interpretations may be valid. Her provocative yet wary attitude, her stylized sex appeal and above all her recumbent position on the table support the fancy that she is herself the stake that is being played for. We may notice that for all her subtle display of charm she has a cold-hearted appearance, suggesting an attitude of calculation on her part and a disappointment in store for the victorious gamester.

Does Beckmann mean to suggest that the story is primarily one of infatuation and deceit? This would not be a new theme: there is a long tradition, going back to the sixteenth and seventeenth centuries, of wooers being led by the nose and fleeced at the gaming table. The old painters were mainly concerned to point out the vanity of human desires and ambitions, but Beckmann goes further: he shows how desire, stimulated by allurement, breeds suspicion and aggression. Another familiar theme, that of rogues cheating each other, also falls short of Beckmann's incisive purpose. We are no longer concerned with deception on either or both sides: the strange behaviour of persons and objects seems to indicate the collapse of even that cynical order

which governs and preserves the world of gangsters. Tension and mistrust have reached a point at which calculation fails and the world is abandoned to blind mechanical impulses of violence. We may well relate this to the outbreak of war; the picture, as already mentioned, was begun in 1939.

The small group sitting at the table in front seem unaware of the tense situation, but doom is in store for them as well. A croupier, overcome with excitement, advances greedily in a creeping attitude. The bankers are suddenly armed with great swords, but, as they step noiselessly forward, two ghostly figures in masks appear beside them. Laying a hand on the shoulder and pocket of the demented creatures, they hold up time bombs on which the fuses are burning. A world or a society whose greed has become insatiable is collapsing into ruin. Beckmann foresees its hour of catastrophe, and the war confirms the rightness of his prediction.

Perseus 1940-1

Beckmann reverted time and again to the theme of brutality and violence—not, we may be sure, because it afforded him pleasure, and also not with any hope of shocking his contemporaries into better ways. He was a man in search of an explanation, and he strove to attain it by the detached analysis of human passions. Mythology and history served this purpose as well as the present day, and he often saw current events in terms of ancient destiny. A striking example is the triptych *Perseus* of 1940–1 (page 67). This was the first of his great triptychs to be painted under the immediate impression of the Second World War, and is the only one in which we find direct allusions to the conflict. The right-hand scene is lit by a fiery glow, and in the distance we perceive a grim nocturnal landscape with houses burning and collapsing. In the lower right corner a figure looks out from the canvas with an expression of pain and horror, lifting a hand to its eyes in a gesture the more frightening for its restraint.

'Grievous days,' wrote Beckmann in his diary on 11 September 1940. 'London and Berlin bombing each other. What is to be the end of it?' There was much bombing of Amsterdam, too. On 9 September he wrote: 'Quiet death and destruction are all about me, but I am still alive.' Three days later he wrote: 'Many things are easier to bear if one thinks of the war, or indeed the whole of life, as a mere scene in the theatre of infinity.' The image of the 'world stage' recurs here in a wider form, and we shall consider later what he meant by the reference to infinity. For the present we may note Beckmann's reaction: the more he suffers from events, the more he seeks to dominate them by taking a universal view.

The burning houses are not the main motif of the right-hand panel. Its chief feature is an enormous cage full of monstrous figures with human heads and legs like birds. In front are the branches of a tree extending mysteriously into space; on it is perched a birdlike creature with the face of an aged man. The scene is apparently based on an old creation myth which Beckmann discovered in a curious source and which speaks of worlds that went wrong in the beginning, so that the gods destroyed them. 'According to the tablet,' this source tells us, 'the "lord of the angels" plunged mankind into the abyss . . . and the great gods afterwards created men and women with the bodies of birds of the wilderness: "seven kings, brothers of one family."' In a different passage the source speaks of the World Tree of Norse and other mythologies, the sacred ash with an eagle dwelling at the top. The race of 'birds of the wilderness' was of course destined to make way for a new creation. We need not go further into the story here, but it may be useful to bear in mind the account of successive creations and their violent extinction, a symbol in Beckmann's eyes of unintelligible suffering.

In the central scene Perseus, Andromeda and the sea monster are combined in a single, bold, hieroglyphic drawing. This recalls Beckmann's symbolic compositions of the middle twenties, but we see at once how far he has come since then. Apart from the expressive style and the solidity, now emphasized and now subdued, of the human and animal bodies, we are impressed by the dynamic effect of the composition as a whole. The 'picture symbols' have taken on the robustness of living beings, as though an abstract artistic concept had turned into disturbing reality—triumphant, mocking and overbearing. Although the painter has created this disconcerting impression, he seems at times to be alarmed by it himself. One entry in his diary reads: 'The self-born gods rebelling against their inventor? Well then, I must endure this too.'

The picture shows the mighty form of the hero, who is apparently on the point of embarking, against the background of a yellow-streaked sea under a grey sky. Small clouds seem to be in rapid motion, foreboding a storm. Two sails appear on the horizon, which forms a powerful curve rising from right to left. It would be hard to imagine a greater contrast with the calm solemnity of the horizon in the centre panel of the *Departure*. The scene has a dramatic and baleful atmosphere, though there is nothing to account for this in the Perseus story, in which Neptune's curse is broken by the slaying of the monster and the rescue of Andromeda. We must remember, however, that Beckmann was fond of re-interpreting mythological themes and that he often conceived them in far from traditional ways (cf. *Odysseus and Calypso*, page 69). In the present case it is clear enough that Perseus is not depicted as the noble hero rescuing those in distress and confounding the enemies of order. On the contrary, he looks more like a pirate, or a Viking after a successful raid. Similarly the bleeding monster is more like a pantomime snake than a ferocious dragon, and Andromeda is little better off than when she was chained to the rock. To understand Beckmann's purpose in thus interpreting or transforming the myth

we should have to follow the course of his speculations on the history of symbols, including fanciful inversions whereby the serpent plays a beneficent role and the strong-arm hero an unfavourable one. This would lead us too far afield, but we may approach the matter from a different angle, namely that of contemporary events.

The picture's relevance to the war situation has always been recognized, but owing to the conventional application of the Perseus legend it has been over-hastily interpreted as representing the hope of an Allied invasion freeing Holland from the clutches of the German army. The figure of the brutal, red-eyed pirate makes this hard to accept unless we attribute cynical intentions to the painter, and in any case, as Charles Kessler has pointed out, it does not fit the immediate historical situation. When Beckmann planned the central scene of his triptych, the catastrophe of Dunkirk was still a vivid memory. Far from expecting an Allied landing on the Continent, the question was whether the Germans would risk invading the British Isles. Plans for the invasion had long been ready, and dates for carrying them out were envisaged several times in the autumn of 1940. Whether or not Beckmann had heard of 'Operation Sea Lion', he understood his countrymen's ambitions and was certainly capable of imagining it. If we allow our thoughts to stray from Perseus to Siegfried, we may have a better idea of the role assigned to this primitive warrior figure. If there is any thought of an invasion, it must relate to the Nazi designs on Britain. However, it would be equally appropriate to connect the picture with the rape of Holland or the impetuous German advance of May–June 1940, which defeated the French and drove the British into the sea.

In the left wing of the triptych we seem to be in an Amsterdam bar where people are trying to survive the war as best they can, in the full consciousness that they depend on one another. A girl of the type to be found in a sailors' dive is playing the accordion; behind the counter is an Indonesian cook. We are a long way from world history or the great mythological themes; but the commonplace scene evidently has a deeper meaning to Beckmann and becomes the vehicle of an unexpected message. The clue is given by the cook's enormous ears: in Hindu and Buddhist tradition such ears denote divine power, and Buddha himself is depicted with them. Even if it were not for the ears, we might notice that the cook has Buddha-like features. We do not know if this is a mere suggestion or if the cook represents an actual Buddha, but in either case the association is important. Beckmann took a keen interest in Buddhist as well as Hindu lore, and he conceived the Buddha's presence and teaching as the antithesis to the bloodstained mythology of war heroes and imperious deities.

The left-hand picture thus constitutes an admonition and a means of interpreting and transforming the vision of horror presented by the remainder of the triptych. The gods and heroes of the old mythology are no better than brutal adventurers or irresponsible war-lords. To lose a battle or a war will not bring them to their senses: disasters are part of the day's work. But

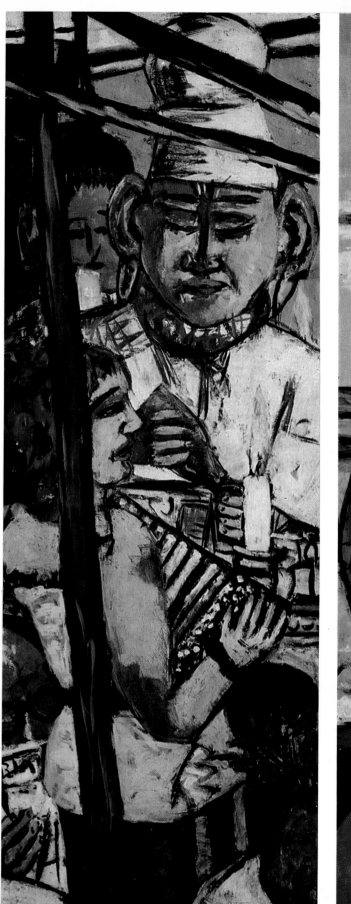

there is also the way of renunciation and non-violence. It generally manifests itself in unimpressive forms, but insight is often to be found where we least expect it.

Self-portrait in front of an Easel 1945

Beckmann painted more self-portraits than any other artist of our century. But Rembrandt had a similar passion, and there is some significance in the comparison. Both painters were concerned not merely to explore their own features and personality, but to study humanity in and through them. This sounds an old-fashioned aim, and we know that most artists of Beckmann's generation pursued different ambitions. Rather than taking the subjective and individual as a basis, they preferred to investigate general laws and to seek reliable constructions in the realm of form. The two standpoints are probably irreconcilable, but we should not be in a hurry to label one progressive and the other backward. Beckmann always regarded self-understanding as paramount: he believed that no external system could relieve a man of the duty of constant self-examination, or take away the continuous responsibility of the individual for his own destiny. This may seem to many a moral rather than an aesthetic viewpoint, but it is scarcely one that has outlived its usefulness.

As we saw in the self-portraits of the twenties, Beckmann was fond of displaying himself in roles and was given to exaggerating these, out of a mixture of irony, self-criticism and sometimes arrogance. In the thirties this form of play-acting disappears; the artist had come to terms with himself and was concerned not to plumb the extremes of his character but to represent this or that specific problem. During the war he produced a number of symbolic pictures identifying himself with such figures as an acrobat on a trapeze, a circus manager in a caravan or an actor on stage. He also painted at that time the remarkable *Self-portrait in Pink and Yellow*, with its enigmatic expression suggesting that of an enlightened yogi. The simple, and remarkably small, *Self-portrait in front of an Easel* of 1945 (page 35) bears some relation to this work but scarcely requires interpretation: in it, Beckmann is clearly concerned with himself purely as a painter. For this very reason it is of especial interest. The first thing we notice is that his powerful physique, to which he gave prominence from the late twenties onwards, is here not at all in evidence. The surrounding space is also reduced to a minimum, so that the picture consists merely of the painter's head and the canvas, together with an unseen mirror which must be imagined in order to understand it visually. It is doubtful whether Beckmann in fact used a

mirror—it was not his custom, and he did not need to—but he clearly wished to convey the familiar effect of looking at one's own reflection in close-up.

As everyone knows, this is a complex experience, in which it is difficult to form a clear notion of oneself. The face in the mirror generally remains obstinately distinct, and the harder one looks, the less one apprehends one's own features. The picture brings this out effectively, but there is another consideration. Beckmann is not merely contemplating himself, he is at work as well. We feel that at any moment he may make a move, his hand may be raised to the canvas to record some feature or to complete the painting. The fascination of the work is that it combines strict concentration with equally strict relaxation. The latter phrase is of course a paradox, intended to convey the strength of will with which everything irrelevant is excluded: the painter has created a sort of vacuum within which he can react simply and solely as an artist. In this sense his forehead, eyes and cheeks are 'relaxed', while the compressed lips bear witness to the energy and training that have enabled him to acquire and maintain the power of discernment and concentration. We may also guess how it is that his works so often show a singular combination of force and tenderness. The painter looks out as though from a fortress that he has built in and around himself, in order to see clearly and to work, despite his own feelings, with delicate objectivity.

Turning to the workmanship of the painting, we are also fascinated by Beckmann's restraint and economy of means. This is not so in all his pictures: at first glance we often feel the opposite, though it can be observed that in important details he always chooses painstakingly among the available possibilities. But in the present case he has evidently worked to a clear formula from the outset. This is seen first of all in the composition. The effect of space is given only by the stretcher projecting from the left and the unusual modelling of the skull, indicating a source of light directly overhead. The spatial effect of the head is limited, moreover, by the absence of light from the sides and because the illumination of the artist's cranium is offset by a background of nearly the same colour. On the left of the picture the background is divided by colour in such a way as to produce an interesting, somewhat tense, correspondence between three verticals: the line in the background, the contour of the skull and the stretcher. This does not exactly create a field of movement, but it suggests that something in the area is happening or about to happen. The short line of the shoulder, disappearing behind the stretcher, completes this effect and confirms the impression, already mentioned, of some imminent move on the painter's part.

The composition in general is limited to flat planes, and is greatly simplified by the fact that the upper part of the body is not given a volume of its own. Heavy outlines divide it visually into sections which correspond more or less to portions of the background. The range of colours is also muted: extremes of black and yellow are present, but are linked by a gamut of subdued medium tones. The main colour effect comes from the brown of the artist's flesh and of the

background; the green shirt-front with its neighbouring red is also of importance. A refinement is introduced by the grey of the painter's blouse or jacket; it is really a porous black through which the white canvas can be seen, and thus relates directly to both the dark and the light values. White, again, forms a border to the dark rear edge of the picture on the easel.

The achievement of such an impressive effect with such economy of means is a *tour de force* and was no doubt meant as such. In addition we may suppose that the sovereign ease with which the master displays his art and idealizes his own person is an expression of the release from tension due to the prospect of an Allied victory. The last winter of the war was one of heavy privation, and the circumstances of Beckmann's life are reflected in his appearance. But the reward of endurance was at hand, and perhaps for a time the world might actually come to rights.

Removal of the Sphinxes 1945

The end of the war did for a while cure Beckmann's melancholy, and he spontaneously reverted to the glowing palette of his happiest days. This relief and this memory of the past found vivid expression in a picture celebrating the liberation of France. Beckmann's joy at this event may have been increased by his long-buried hope that, when the armies withdrew, he might once more be allowed to visit Paris and his beloved Riviera. He began his picture on 25 March 1945. France had had its own government again since the previous August, but Holland was still occupied: the German troops were not disarmed and sent home till the beginning of May. Beckmann painted vigorously during May and June, but did not finish the work until autumn. The title of the painting, *Removal of the Sphinxes* (page 72), appears in his diary for 2 October. He was not in fact allowed to travel to France until 1947; he reached Paris on 25 March, exactly two years after the painting was begun. On the 28th he wrote in his diary with unusual cheerfulness: 'Fine, fine, everything fine—slept marvellously. Nice . . . Place Municipale . . . grapefruit . . . green sea . . .'

The picture shows a dazzling beach with a glorious blue sea beyond. The bright horizon is in restless motion, but the effect, as in a pleasant dream, is bracing and not alarming. In the front, beside a curious pole composed of sections, is a blood-red pedestal or block on which are laid an unsheathed sword and a dark, glinting helmet. Immediately behind, as if on a film set, is a coloured triumphal arch of lively design: the letters ARK can be read on one side and, on the other, part of the word VICTOIRE. In the middle distance is a white building with a portico in antique style. Between the two structures is a curious vehicle apparently meant for a gun

carriage: it is moving to the left and pulling after it a cart in which we see, behind bars, the sphinx which no doubt gave the painting its name.

The general image, as the presence of the arch confirms, is that of a Roman triumph, and the figures behind bars would in this case represent defeated German generals and politicians. Despite their captivity they may be expected to look haughty and supercilious; Beckmann no doubt imagined this, quite correctly as far as some generals were concerned. But it is possible to read more into the picture. He appears to be suggesting that the captives are being led to execution. In this light the pole and block on the left take on the semblance of a guillotine, and the cart recalls the tumbrels of the Reign of Terror; the upright figure in a red cloak beside the blond sphinx is clearly the executioner. Nor is this all. The sphinx in the tumbrel is wearing royal ermine, and her expression can be seen as a queenly one. This confirms the reminiscence of the French Revolution, and we can well imagine the strains of the Marseillaise ringing out. At this point, of course, the history becomes confused. True, Marie Antoinette was of German race and the French people saw her as a symbol of oppression, but it seems far-fetched to identify her with Hitler's armies. However, perhaps we should not be so precise in our interpretation. The picture is a kind of kaleidoscope presenting variations on a theme: the theme is France or the liberation of France, while world history provides the variations.

Other details are not clear either. The sphinxes on top of the triumphal arch are evidently intended as personifications of France, and they differ expressively from the blond monster in the tumbrel. Their head-dress, however, is curious: that on the right suggests Marianne with her Phrygian cap, while the other may recall the head-gear of the victorious General de Gaulle. Is the red flag in the background intended to symbolize the Communist victory in the elections of October 1945? At all events, it combines with the white sky and blue sea to form a majestic *tricolore*; blue, white and red are in fact the dominant colour motif of the entire picture.

It must have been a joy to Beckmann to produce a kaleidoscope of this kind, in which the pictures shift and recombine at the slightest touch, in full accord with his conception of history as a succession of *tableaux* in the 'theatre of infinity'. Seldom, in fact, did he present one of these scenes in such bright, resonant colours. This must be ascribed to the rapture of the moment and the liberation from twelve years of pressure and anxiety, which had more than once afflicted the artist with panic, especially in the years after 1940. One last curiosity in the painting is that Beckmann presents both nations, the French as well as the Germans, in the guise of sphinxes. Perhaps he meant to suggest that there is something inhuman, cruel and incalculable in every human action, or simply that human nature is an enigma, as history is constantly reminding us.

Self-portrait 1946

Begin the Beguine 1946

Beckmann did not continue for long to paint in the cheerful tonal range with which he had celebrated the end of the war. The next few years showed how deep were the wounds he had received and how difficult it was to take up the thread of life as it had been before the outbreak of murderous lunacy. After the heavy trials and exertions of the war years, he suffered from frequent bouts of exhaustion. The idea of a move to the United States was again on the *tapis* and Beckmann's American friends were doing their best to bring it about, but at this time it seems to have inspired him with mixed feelings. He was, it must be remembered, over 60 and by no means in perfect health. This may be part of the reason why his palette again underwent a change: from 1946 it was dominated by dark tones giving a sense of concealment and mystery. The themes of his post-war pictures are for the most part equally mysterious: some are so confusing to the ordinary spectator as to leave merely an impression of dreamlike unreality.

An important picture of this type is *Begin the Beguine*, painted in 1946 (page 77). The title is borrowed from a dance tune, and a dancing couple can be discerned in the centre of the compo-

sition, but our attention is also challenged by the oddly dressed figure on the right holding a large key. In the background are huge birds resembling pelicans, while below on the left a female figure stiffly holds up both her arms, which are bound and mutilated. The pictorial beauty of the work is such that the spectator may be less curious as to its interpretation, but the expressive gestures and intriguing symbolism present a problem that cannot be wholly ignored. This is especially the case if we suppose that the symbol of the key is directly associated, as in fact it is, with the 'hermetic' quality of Beckmann's paintings. The lanky figure has nothing to do with St Peter but represents Hermes Trismegistus, whom the Gnostics of late antiquity identified with the Egyptian Thoth and to whom they attributed the mystical writings known as the Hermetic Books. This Hermes was regarded as the custodian of mysteries which enabled man to break through the bonds of nature and achieve the ecstatic awareness of spiritual freedom. Considering Beckmann's interest in the history of religion and the occult, it is no surprise that he should be aware of these theories, but it is interesting to observe the context and the type of everyday events to which he relates them.

The idea for the picture was apparently furnished by some commonplace party: this is confirmed by the dress of the dancing couple and the modern effect of the carpet, curtain and wall decoration. A broken bottle on the floor recalls the painter's love of champagne, well known to his many various hosts; it is inscribed ROI, no doubt representing Irroy, the name of his favourite brand. The exhilaration of wine and the dance symbolize ecstasy, inspiration and a dreamlike sense of escape from the laws of gravity. There is evidently a mystical contact between the elegant female dancer and the youth holding the key. We see her beginning to float in the air; one of her legs under the evening dress has already turned into a wing, but the raised right arm suggests that she is not yet in a weightless state. She embodies the ancient metaphor of the soul aspiring upwards, and the sprouting of her wings is linked with the manifestation of the divinity—Hermes Psychopompus—who guides souls from this world to the next. The strange birds in the background may be taken as emblems of freedom. The woman squatting on the ground, however, is the exact antithesis to the soaring dancer and seems, in her tortured impotence, to symbolize the pain of hopeless longing.

This picture displays the artist's visionary talent in a new light: instead of great events and historical analogies, we are shown how casual experience may take on a deep, universal meaning. A trivial occasion suggested the associations with which the painting is imbued and which give it extraordinary power. The effect is enhanced by the unusual and intense tonal resonance: in particular the different greens give an impression of dreamlike beauty. Metallic blue and violet are combined with extreme audacity, and the gamut is completed by reddish brown. Yellow and orange details supply transitional effects, and shades of grey, exquisitely differentiated, echo each other here and there. If the use of colour in this picture is compared with

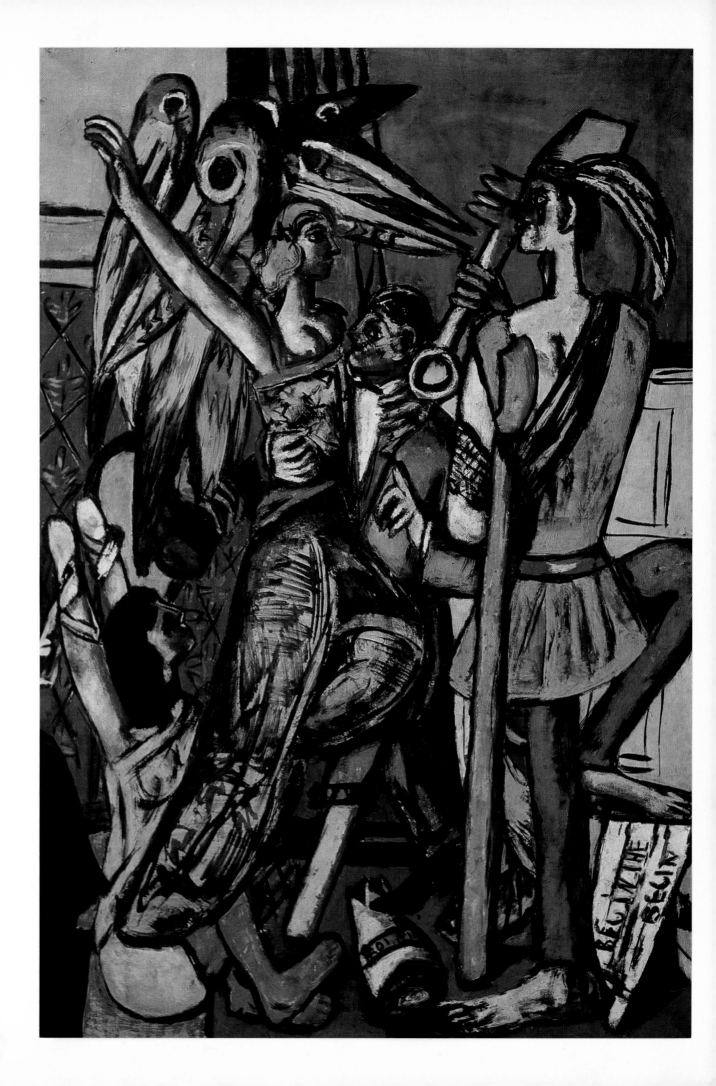

subsequent works by Beckmann we may regard it as modest in its striving after unreal and eccentric effects; but if we compare it with earlier paintings, the evolution is clear. The artist is breaking entirely fresh ground as far as content is concerned, and from this point of view the work is not an isolated incident but a pointer to what lay in the future. Despite the end of the war and the possibility of again coming to terms with the actual world, Beckmann's sense of reconciliation was short-lived: in the years that remained to him he showed a more and more pronounced longing for escape, and his conflict with reality took on almost tragic proportions.

Woman in front of a Mirror
with Orchids 1947

Woman in front of a Mirror with Orchids 1947

In spite of grave doubts as to whether he was equal to the change, Beckmann decided in 1947 to accept a teaching post at Washington University in St Louis, Missouri. He thus crossed the Atlantic in the same year in which he was at last allowed to revisit France. His first impressions of America are recorded in a lively and at times enthusiastic vein; New York especially continued to stimulate his imagination. The atmosphere of St Louis was friendly, and Beckmann adjusted himself as best he could to the fact that he was now a 'famous painter' and an object of public interest. His fame had gone before him, thanks to American friends, especially his agent, Curt Valentin. On the evidence of his diary alone it may be said that he found his feet extremely quickly. Despite teaching obligations and incessant parties he very shortly began painting again, as though the trip to America were a mere excursion.

We may, however, be puzzled by one of the first pictures he completed at St Louis, the *Still Life with Candles and the wooden Bust of a Woman* (1947). The misleading title *Woman in front of a Mirror with Orchids* (page 79) probably relates to a preliminary design executed in Amsterdam. The solemn motif of the candles seems to have come to the forefront in the St. Louis version, and we are struck by Beckmann's reversion to the complex formula, rich in associations, of the upright and the overturned candle. This, it may be recalled, first figured in his work at a time of internal and external crisis, symbolizing misery and death in the frightful painting *The Night* of 1918–19. Later it became the central feature of a *Vanitas* symbolism, used most effectively in the heroic still life *Fallen Candle* of 1930 (page 34). Subsequently, although Beckmann continued to use the motif of candles he did not represent a pair of them in this way. If, in 1947, he reverted to this ominous formula and made it the centre of an ambitious still life, it was not because he had run out of ideas but because the theme had taken on a new content and a new relevance in his eyes.

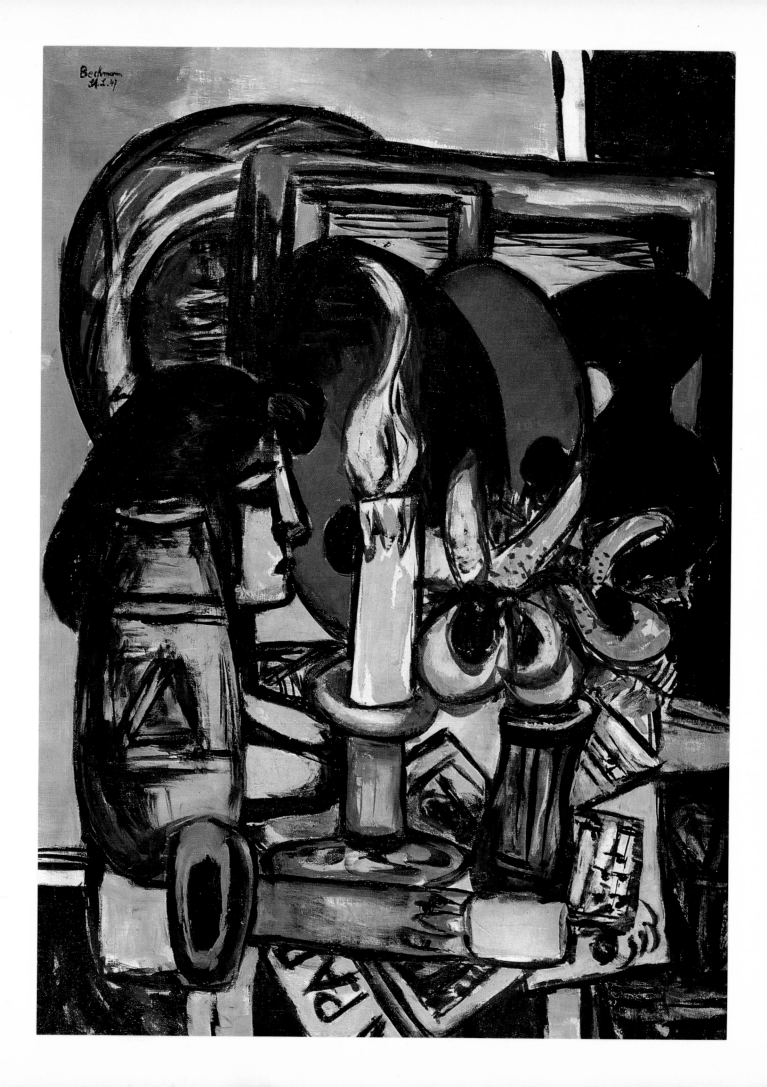

Beckmann was no doubt conscious at this time that he was taking chances with his health. Although the diary says little about it, he must have realized that his ruthlessly energetic way of life was dangerous in view of the signs of heart trouble, which were becoming more and more insistent. However, he paid no attention and worked harder than ever, and also more rapidly, as can be seen in his work. Not that its quality suffered in any way, but a new sweeping manner appears in the delineation and the fluent application of paint. The style of Beckmann's last years is characterized by large, often uniform surfaces, monumental figures and a lapidary conception of the object. All this may be seen in the present picture, as may the taste, mentioned above, for unreal colour effects. These are intensified here by the play of light and the peculiar shadows, conforming to no physical law. A good example is furnished by the large palettes, standing at the end of the ochre-coloured table in front of the strangely interlocked mirrors, and forming with them a crowded complex which no doubt has its symbolic interpretation. There may, in fact, be more ways than one of explaining the dark shadows on these brown palettes that look as if they were in motion. It is probably no accident either that the mirrors are dislodged and give only a vague impression of reflected light. All this darkness and confusion may be linked with the wild flickering of the outsize candle-flame, which is obviously destined to burn out in a brief space of time. The palettes, we may say, belong to this world, while the mirrors suggest a further dimension. Although the whole composition is seen against a beautifully toned interior wall, except on the right where it projects into a blacker darkness, we feel that a mysterious barrier separates the objects that are closer to the spectator from those further off. In the former group are things that we quit reluctantly and for whose sake it is worth burning the candle a little longer—the exquisite orchids, music, a woman's head with strong features- a blue vase and a green sheet of paper which may read PARIS: over this inscription the extin-guished candle has fallen like a heavy log.

This thought-provoking work is clearly in the same category as Beckmann's many *Vanitas* pictures of the 1920s, but every detail of the traditional theme now seems to be imbued with a personal content. From the time of his arrival in New York we often read in his diary, for instance in reference to the inescapable round of parties, the English expression 'Vanity Fair', which seems to have struck him by its pithiness as well as recalling his old theme of the 'world theatre'. This theme once more became essential to his philosophy, both in presenting a calm front to the events of the day and in seeking to discover the reason for the theatre and the meaning of its shows. Almost all the pictures of his last years suggest this question and leave no doubt as to his perplexity. The furthest background, which has long symbolized the unknown, consists more and more frequently of a black space; there is also a tendency to set bright colours against a black ground or to make objects look like coloured phantoms in the dark. In the still life of 1947 there is only a suggestion of this; but the black outlines are much emphasized, and

the opposition of these to lemon yellow, violet, chrome green and sky blue must have seemed at the time to indicate no small degree of alienation in terms of colour.

The Tempest 1947-9

Beckmann's new style of colouring was intensified to a startling degree in a grandiose fantasy to which, shortly before its completion, he gave the title *The Tempest* (page 82). This work too was begun in Amsterdam, and for a year or two was known as 'Jupiter'. Its title was changed after the artist had worked on it vigorously in May 1949: it was probably then that he made the shrill, aggressive, turbulent colours stand out as they now do against the black background. The explosive effect may owe something to an actual storm, but the work has more than a terrestrial meaning. It is intended to depict a 'cosmic storm' in outer space: the round shapes are planets and moons, and the blackness is that of infinity. The grotesque figures with trumpets seem to be making a sport of creating and destroying worlds; a huge heavenly body is exploding at the top of the picture, while the bright red disk in the foreground represents a planet on which life is just beginning. This interpretation may seem far-fetched, but there is good evidence for it in statements by Beckmann himself. As for the spirits with trumpets, they seem to be related to the curious 'gods' in a free-verse poem composed by Beckmann in the thirties and reprinted in his essay 'On My Painting':

'Fill up your gourds again with alcohol, and hand up the largest of them to me. Solemnly I'll light the great lights, the giant candles for you now in the night, in the deep black night.

'We are playing hide-and-seek, we are playing hide-and-seek across a thousand seas, we gods, we gods in the dawn, at midday and in the black night.

'You cannot see us, no, you cannot see us but you are me . . . that is what makes us laugh so gaily in the dawn, at midday and in the black night.

'Stars are our eyes and the nebulae are our beards . . . we have people's souls for our hearts. We hide ourselves and you cannot see us, which is just what we want in the dawn, at midday and in the black night.

'Our torches stretch away without end . . . silver, glowing red, purple, violet, green-blue and black. We bear them in our dance over the seas and the mountains, across the boredom of life.

'We sleep and our brains circle in dull dreams . . . we wake and the planets assemble for the dance across bankers and fools, whores and duchesses.'

Beckmann is clearly striving towards a perspective in which the 'theatre of the world' opens out into the 'theatre of the universe'. It is a macabre touch that the trumpets of his celestial beings resemble those blown by harlequins in the carnival scenes of twenty years ago. The objects and forms in their shrill colours emerge and disappear in a fascinating manner, and no less fascinating, it seems to me, is the breathtaking suggestion of universal space in which there is neither light nor position. These two effects are in fact dependent on each other. The figures are so arranged that we cannot take up a fixed standpoint at a distance from them. The composition is open on all sides, and the violent handling of space gives the impression that we might suddenly be caught up in the movement of the cosmic spirits. This uncomfortable illusion is mainly due to the fact that their trumpets are drawn in such strong perspective. While the lower one opens out sharply in the spectator's face, at the top of the picture the black mouth of the instrument is partially covered by a wispy cloud. Thus the effect is directed towards the spectator in one case and away from him in the other. The result, in combination with the curious colours and the dead background, is to give an impression of absolute, unfathomable space. Beckmann grappled for decades with the problem of space, and he seems in this picture to have attained the power of representing the incomprehensible in an almost straightforward manner, so as to leave only the problem of arranging his figures. It is especially noteworthy that he achieves this effect without resorting to abstraction. The term 'absolute painting' has been used, with some justice, in relation to this work, and at the same time the representation is objective and tangible in the highest degree. Moreover, the conceptual content of this highly visual scene, though it may be enigmatic, is far from being neutral or insignificant.

Columbine 1950

In summer 1949 Beckmann moved to New York. His contract at St Louis had expired, and he received an appointment at the Brooklyn Museum Art School. Before taking it up he spent two strenuous months giving a summer course at the University Art School in Boulder, Colorado, a job he had taken for financial reasons. He taught a similar course in the summer of 1950 at Mills College in Oakland, California; the invitation was attractive in itself and gave him a welcome chance to visit the Pacific Coast. He was much impressed by San Francisco, and wrote with enthusiasm in his diary of the eucalyptus forests by the ocean. Altogether the stay at Mills College was a success and seemed to be worth the risk he had taken with his health, though he had attacks of nerves beforehand. Two days before his departure from New York he was working on a picture which he altered so much from its original plan that he himself was alarmed by it.

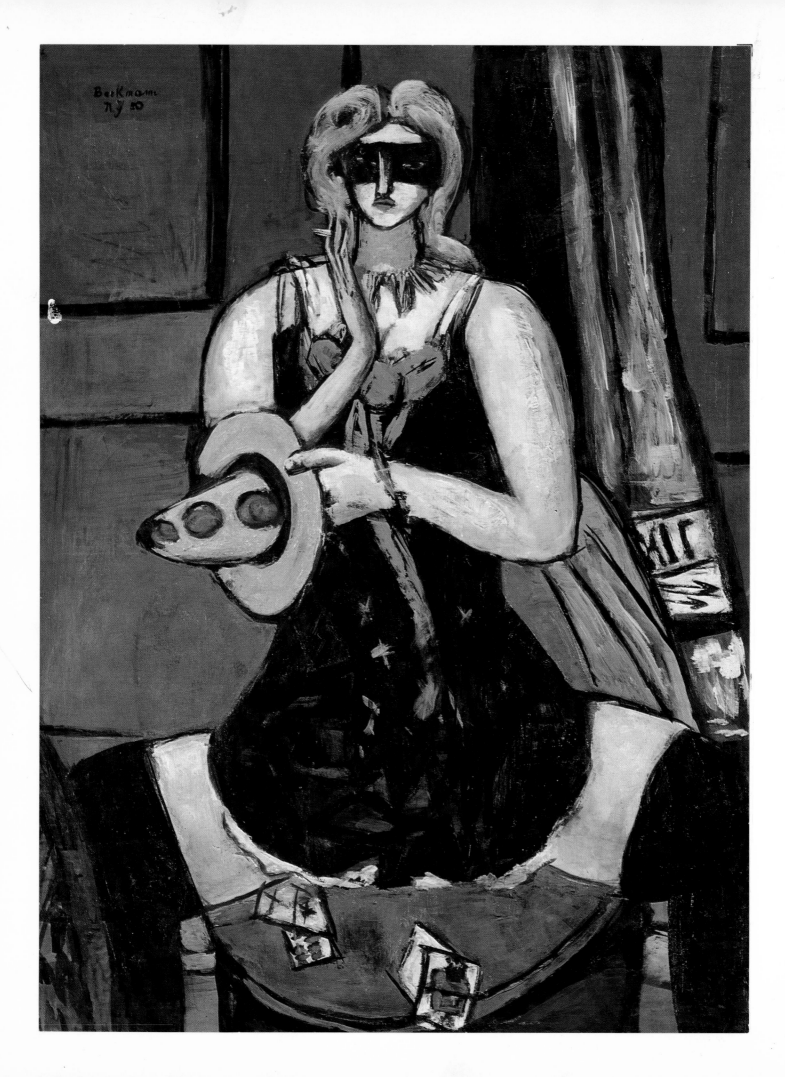

In his diary he wrote with apparent flippancy: 'Painted "Yellow Stockings" all over again—I must be crazy. Well—Jesus Christ!'

'Yellow Stockings' was a painting previously mentioned in the diary as 'Yellow Pierrette' and now known to us as *Columbine* (page 84). Scarcely a trace of yellow remains: the colour scheme expresses alienation and the whole theme is macabre, as Pierrette has turned into a *femme fatale* with some traits of a death goddess. The background is a large wall surface uniformly decorated in an aggressive lilac tone; this is broken on the right by a black space with a green curtain blowing forward. Columbine, in a black mask, sits in the foreground on a chair upholstered in bright blue; her legs are wide apart and reveal the drum-like surface of the seat, on which a few playing-cards are lying. This area is framed and emphasized by her black stockings, the pale flesh of her thighs and the smooth dark-blue petticoat. In the upper part of the picture the woman's body is composed like a monument, with hefty shoulders, a nondescript bust and a narrow waist; the head on the stiff neck wears a threatening expression. She has on a chrome-green kerchief and is holding with the thumb of her left hand a pierrot's hat, the colour of pink candy. Her right hand is raised to her lips, and the ghost of a cigarette is seen between the unnaturally elongated fingers. Pale red and blue tones are curiously mingled in her dishevelled hair; the flesh-tints are also disturbing, composed of pale ochre and pinkish grey, through which the dark priming can be seen here and there. The total effect is one of obscene fascination charged with foreboding. It is hard to say which is more frightening, the sharply discordant tones or the woman's ghostly anatomy. Her body looks as though it had been wrenched apart and reassembled in an inhuman, hieroglyphic form. An almost perspectival effect is created as the eye travels upwards, and this enhances the threat which we feel emanating from the uncanny figure that faces us.

We have already drawn attention to Beckmann's use of the *femme fatale* theme, and in *The Organ-grinder* of 1935 (page 56) we encountered the Hindu goddess of death who devours what she has herself brought forth. The woman's attitude with legs spread wide apart is relevant here: we find it in Sumerian seal-impressions, where the goddess squats in this position while awaiting her prey. The notion is that the womb which conceives is also that which consumes, so that death and sexuality are intertwined. This brings us back to the thought of the *femme fatale* and to the challenging coldness which stares at us from the picture.

There is little doubt that Beckmann thought of this Columbine as a monster, but to my mind she also exerts a mysterious attraction. The mythological aspects were well known to the artist from the thirties onwards, but the genesis of the picture is different from that of *The Organ-grinder* or other, more speculative, compositions. We feel that the hieratic figure came into being spontaneously: we can imagine how the artist helped it to birth despite his fears, how the yellow Pierrette turned by degrees into the dark phantom which now demands our attention.

There is no question of a mythological subject in the ordinary sense. The character remains a modern one, but it is as though the artist had undergone an archaic experience while painting it. Psychologists might have more to say about this, and about the suppressed excitement in the ejaculation 'Well—Jesus Christ!', which is not typical of Beckmann and which I have found nowhere else in his diary. In any case, it would seem that he read a present-day meaning into the picture, and he may well have regarded it as an apotropaic formula. As he prepared to leave for California he would have reflected that he had so far eluded the danger which hung over him and of which the picture constituted a grim reminder. This is made plain by the cards on the chair in front of Columbine's lap: they appear to have been hastily thrown down, but I feel certain that they represent fate and a possible decision. It is probably not by chance that the two cards closest to Columbine's body are marked with rough crosses, suggesting death.

Falling Man 1950

Beckmann's death came as he would no doubt have wished it—suddenly, in a matter of seconds, after days of intensive work in which his ninth triptych was completed. The date was 27 December 1950; he was taking his usual morning walk and suffered a heart attack at the corner of West 69th Street and Central Park. The previous evening he was still working hard on the centre panel of his triptych *The Argonauts* (page 36). As his wife wrote later: 'Finally, in the evening, he painted in, quite lightly, the uncanny reflections on the young man's body. Then he came, pale and sweating, into the living room and said, "Well, that's the very last stroke I'll do on it."'

The Argonaut triptych was Beckmann's testament, and he was fully aware of this while painting it. The centre panel is distinctly related to *Young Men by the Sea*, the work which launched him on his artistic career. This is especially clear if we recall the pastel discussed at the beginning of this book (page 7): not only the theme of nudes by the sea but even the mood of the early work seems to be repeated, though in a quite different context. The centre panel is given a narrative character by the strange phenomena in the heavens and the bearded ancient on the ladder: the young men in the pastel were alone with their thoughts and dreams, but this time the sea and sky give answer, albeit in a mysterious way. We need not be surprised at this or seek to probe the riddle too deeply; a few indications may suffice.

In the first place, the triptych is not closely related to the legend of the Argonauts; it did not receive this title until quite late, apparently as the result of a dream. Previously Beckmann called it 'The Artists': in the left panel a painter is seen at work, and on the right are girls

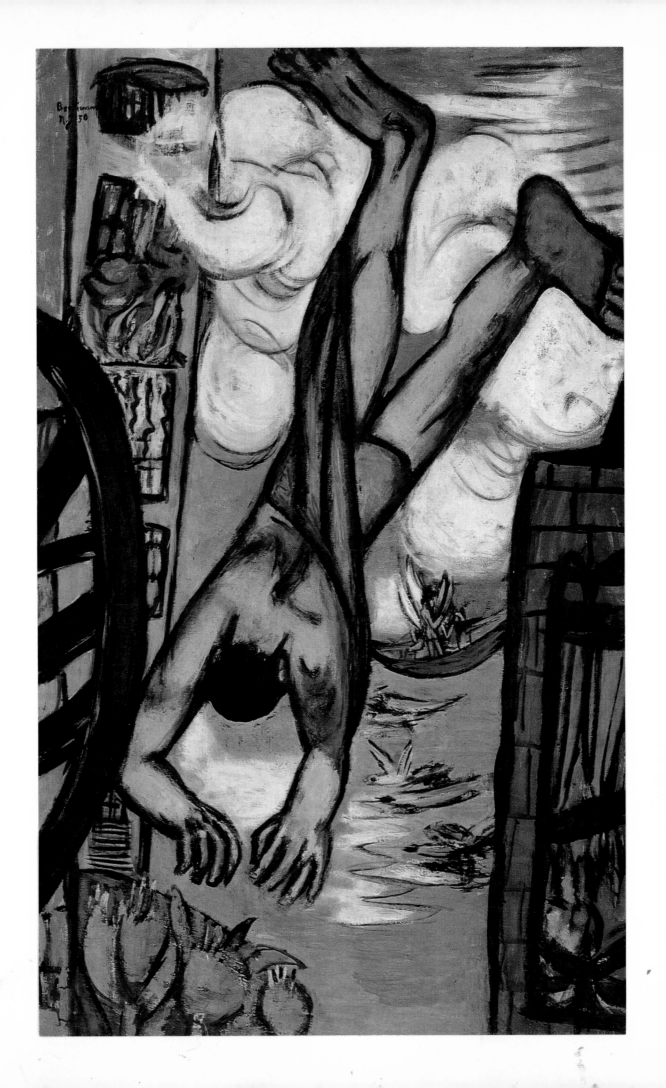

making music. In any case, the painter intended his testament to speak of the hopes and endeavours of those who strive to fathom the secrets of the universe and the mystery of human existence. Beckmann felt solidarity with all such people, and the work is no doubt intended to strengthen his fellow seekers in their perseverance. He himself questioned, often enough, whether human existence had a meaning, but he remained faithful to a working hypothesis which may be expressed by saying that there is a secret message in everything we perceive and experience. He found it stimulating to approach life as if this hypothesis were true, and from time to time he felt it to be strangely justified, though his speculations were defeated by the insoluble contradiction between human consciousness and the boundless universe. 'We must believe in infinite relationships,' he once wrote in his diary. 'They are generally incomprehensible to our minds, but there is no other way of feeling at home in the cosmos.' In *The Tempest* of 1947–9 he subjected this feeling to a test which came close to mockery, whereas in the centre panel of *The Argonauts* he is concerned to strengthen and preserve it. Both attitudes must be borne in mind if we are to understand Beckmann's philosophy. In his later work contradictions are part of the norm, an important fact in itself and one which relates not only to the speculative or emotional content but also to the artist's technique. Pictures painted at a short remove in time may show extraordinary differences of style and especially of colouration.

A final example of this 'contradiction' will make clear the remarkable breadth of range in Beckmann's later style. His *Falling Man* of 1950 (page 87) is one of the finest works of his last years. It was painted between *The Tempest* and *Columbine*, and on a close look we may see resemblances to one or the other. As in *The Tempest*, one of the main themes is infinite space—not, however, the dismal black emptiness of the universe, but the azure sea and sky which Beckmann had painted in the past and in which he now surpassed himself. On the other hand, *Falling Man* is related to *Columbine* by the theme of death: the man is presumably plunging to his destruction, as is borne out by the resemblance of the picture to an early work entitled *Fall to Death*. But the attitude to death is quite different in the two paintings. The terrifying vision of the masked goddess in *Columbine* permits of no identification: she is the embodiment of an inhuman law reducing everything to cold anonymity. Faith has no object, questions are absurd in the face of an indifferent, endless universe. In *Falling Man*, however, we are not confronted by a faceless adversary and, as will be seen, our questioning is not rejected out of hand. The work seems to be based on the conception of death which includes belief in an after life and the hope of liberation from our earthly condition. This is suggested by the central part of the picture, with its dreamlike vision of a boat in mid-air and magical birds against a deep-blue background that might be either sky or sea but is probably meant to transcend both elements. In the boat we discern soft outspread wings and a naked figure; the rest is obscure, but the general impression is of a many-coloured paradise.

From a Letter written by Beckmann

This comparison may serve to illustrate the variations in Beckmann's late style, which reflect not changes in his position as an artist but his long-held opinion that painting is only a means, and that what determines the nature of a work is its subject. Dogmatists of the modern school may find this a wilful attitude, but in Beckmann's view a picture is not the solution of a formal problem but the rendering visible of a specific content. This does not mean, of course, that one may choose any theme and make a picture of it. To Beckmann in his late years, the only fit subjects for painting were those that crystallized into a vision of his own. Such a vision, arising in the painter's mind independently of his own will, appears to him as a species of truth and not a mere invention. We can thus see how it is that Beckmann ascribed intrinsic impor-

tance to widely different types of artistic statement, and adapted his technique to the requirements of each.

This is why, for instance, there is little trace in *Falling Man* of the sharp artificial colours of *The Tempest* and *Columbine*. They are suggested, it is true, in the unreal violet tone of the jewel-like promontory in the foreground and the chrome green of the man's loincloth, but these are merely incidental to the total effect. Another mark of Beckmann's late style is only partially in evidence here, namely the use of bold continuous outlines. These occur in the imposing contour of the falling body, but the burning houses are drawn in a childlike manner, and the rest of the draughtsmanship is sketchy in a way reminiscent of pseudo-dilettantism.

The picture presents a number of puzzling questions, some of which we cannot answer. It may be interpreted, but no doubt inadequately, in terms of traditional pictorial concepts: for example, the severe, almost archaic, formulation of the man's body recalls vividly, and probably not by chance, the falling figures of the 'wheel of fortune' on the Romanesque façade of San Zeno at Verona. The naked bodies with outspread legs, clothed like this one in a loincloth only and plunging down from a mighty spoked wheel into the abyss, represent the medieval allegory of the fickleness of Fortune. He who rises must expect to fall; only a brief span is allowed to each, and in this world there is no abiding stay. One is tempted to regard the wheel-like structure projecting into Beckmann's picture as part of the same allegory, but the artist himself denied this, stating that it represented the railings of a balcony seen from above. This is an important clue: only by imagining the dizzy perspective that it implies can we fully appreciate the confused spatial conditions of the picture. There is, in fact, some reason to think that the painter first designed a wheel and changed his mind afterwards; but we must take his word as to the final intention, which means that the impression of space in the picture is its paramount object, as various other details tend to confirm. Some motifs, on the other hand, are perplexing. Do the burning houses signify that the man jumped out of a window to escape the flames, or are we in the presence of a mysterious world catastrophe? Perhaps the suggestion is only that life in human habitations has become unendurable. The dreamlike vision of endless space presents an alluring, liberating contrast to the claustrophobia of the hive. There is an allusion here to the depressing aspect of New York tenements, and the unusual sensation of looking into upper-storey windows gives a ghostly quality to the narrow rooms within.

Beckmann had in fact used an impression of this kind once before to give an effect of panic. In the first of a series of lithographs published in 1920 under the collective title *City Night* (right) he showed two houses opposite each other. The spectator, imagined as hovering in the air, has a view through a high-level window into a room where two people are being maltreated: their screams are unheard and there is no escape. This work certainly influenced the painting of *Falling Man*. The houses are drawn in the same naïve manner, and there are even repetitions

City Night 1920

of details such as the irregular pattern of bricks in the wall of the house on the right. In the lithograph, it is true, there is no delectable vista, only a sickle moon crammed between two houses. But we may also recall an etching of 1918, in which the spectator is again imagined as very high up and in which the main theme is a vision of the sky beyond a ravine of houses.

Thus *Falling Man* reminds us of the days of Beckmann's youth, in which panic and longing were his dominant emotions. He may have felt that things had not altogether changed since then, but his concern in this painting is clearly to recapture life as a whole, uniting retrospect and prospect into a single vision. He may, however, have used the figure of the falling man to signify escape from the dungeon of existence into the freedom of space.

Beckmann formulated his attitude towards the problem of space many times, and always in unusual language. The various passages read like professions of religious faith: 'For in the beginning there was space, that frightening and unthinkable invention of the Force of the Universe.' . . . 'Space, and space again is the infinite deity which surrounds us and in which we are ourselves contained.' The first of these quotations is from a lecture given in February 1948 at Stephens College, Columbia, Missouri, 'Letters to a Woman Painter'; the second is from a

lecture given ten years earlier at the New Burlington Galleries in London and published in New York in 1941 under the title 'On My Painting'. In the latter lecture he also said: 'It is the strength of the soul which forces the mind to constant exercise to widen its conception of space.' It thus appears that Beckmann was on familiar terms with highly interesting metaphysics of space, and the key concept is that of 'widening our conception' of it.

We will not attempt here to sum up his success in doing so, but it would be wrong to take leave of a picture like *Falling Man* without noting that as he grew older, his representations of space became both simpler and more complex. In the unforgettable centre panel of the *Departure* it is the horizon that plays the dominant role. Later, in *The Tempest*, he ventures to portray space independently of any fixed standpoint. This involved a highly elaborate composition, with colour effects supported by abrupt foreshortening. At last, in *Falling Man*, he achieved a representation of space without recourse to a horizon or to the convergent lines of perspective. Superficially the result appears lacking in artistry, a mere surface that could be described in terms of its component areas. But if we surrender for a few moments to the painterly effect of the blue central expanse, we find that it conveys an impression of fascinating, immeasurable depth. What we have here is in fact neither surface nor perspective: the artist is presenting a vision that eludes these categories, and can probably be expressed in no other way than by the glowing transparency of colour.

Biographical Summary

1884 12 February: born at Leipzig, the third child of a wholesale flour merchant from Helmstedt (later Königslutter), near Brunswick.

1894 Death of his father; family returns to Brunswick.

1894–1900 School at Brunswick, Gandersheim and Falkenburg (Pomerania).

1900 Enters the art academy at Weimar, having been refused at Dresden.

1901 Transfers from the 'antique class' at Weimar under D. Rasch to the 'nature class' under F. Smith.

1903 Leaves Weimar; visits Paris and Amsterdam.

1904 From Paris to Geneva, afterwards to Berlin.

1905 Visit to Jutland.

1906 Death of his mother. Exhibitions in Berlin (Secession) and the *Künstlerbund* in Weimar. Villa Romana prize. Marriage to Minna Tube. Visits Paris and Florence.

1907 Returns from Florence and builds a house in Berlin-Hermsdorf. Exhibition at Weimar. Visit to the Baltic.

1908 Visits Paris. Birth of his son Peter.

1908–14 Artistic success and many personal contacts in Berlin. Withdraws in 1911 from the Berlin Secession.

1913 First monograph on Beckmann, by H. Kaiser.

1914 Volunteers for the medical corps and serves in East Prussia (October), later Flanders and Strasbourg.

1915 October: nervous breakdown and discharge from the army. Starts life again at Frankfurt on the Main.

1916 *Briefe aus dem Kriege* published by P. Cassirer, Berlin.

1917 Exhibition of new drawings, J. B. Neumann gallery, Berlin.

1922 Exhibition at the P. Zingler gallery, Frankfurt.

1924 Collective work on Beckmann by C. Glaser, J. Meier-Graefe, W. Fraenger and W. Hausenstein, published by Piper, Munich.

1925 Exhibition at the Paul Cassirer gallery, Berlin. Divorce, and marriage to Mathilde von Kaulbach. Appointed teacher at the Städelsches Kunstinstitut, Frankfurt. Visits Paris and Italy.

1926 First exhibition in New York at the J. B. Neumann gallery.

1928 Large retrospective exhibition at Mannheim (Kunsthalle), Berlin (Flechtheim gallery) and Munich (G. Franke gallery).

1929–32 Spends winter months in Paris. Pictures in the Kronprinzenpalais, Berlin.

1929 Second prize, Carnegie Institute, Pittsburgh, for the picture *The Loge*.

1930 Exhibitions at Basle and Zürich. Participates in the Venice Biennale.

1931 Exhibitions in Paris, Brussels and Hanover.

1932 Offered post at Munich; refuses after hesitation.

1933 Dismissed from the Städelsches Kunstinstitut; moves to Berlin. His pictures removed from German museums.

1937 Leaves Germany for good after the opening of the 'Degenerate Art' exhibition, in which his work is fully represented.

1938 Delivers lecture, 'Über meine Malerei' (On My Painting), at the opening of an exhibition of twentieth-century German art at the New Burlington Galleries, London.

1938–9 Spends winter in Paris.

1939–40 Awarded first prize in Contemporary European Section at the Golden Gate International Exposition, San Francisco. Invited to teach at the Chicago Art Institute, but unable to accept because of the outbreak of war and visa delays.

1940 Germans invade Holland. Beckmann, in Amsterdam, destroys his diaries.

1940–6 He and his wife live in hardship in Amsterdam.

1946 First post-war exhibition at the G. Franke gallery, Munich.

1947 Travels to Paris and the Riviera. Accepts appointment at Washington University, St Louis, and moves to the United States.

1948 Large retrospective exhibition at St Louis, Los Angeles, Detroit, Baltimore and Minneapolis. Lecture entitled 'Letters to a Woman Painter' delivered at Stephens College, Columbia, Missouri; repeated subsequently in various places and published in English. Visits Holland.

1949 Teaches summer school at the University of Colorado, Boulder. First prize, Carnegie Institute, Pittsburgh. Moves to New York and takes up appointment at Brooklyn Museum Art School.

1950 Awarded Honorary Doctorate at Washington University, St Louis. Visits the Pacific coast and teaches summer school at Mills College, Oakland. One-man show at German Pavilion, XXV Biennale, Venice. Awarded Count Volpi prize.

27 December: dies in New York.

List of Illustrations

Colour Plates

Illustrations in the Text

Black and White Plates

Bibliography

I Max Beckmann's writings, lectures and letters

1 'Im Kampf um die Kunst (Die Antwort auf den Protest deutscher Künstler) Mit einem Beitrag von Max Beckmann'. Munich, 1911
2 'Gedanken über zeitgemässe und unzeitgemässe Kunst'. *Pan*, II. Berlin, March 1912
3 'Das neue Programm'. *Kunst und Künstler*, XII. 1914
4 *Briefe im Kriege*. Berlin, 1916. 2nd edition, Munich, 1955
5 Foreword to catalogue: *M.B. Graphik 1917*. J.B. Neumann, Berlin, November 1917
6 'Schöpferische Konfession'. *Tribune der Kunst und der Zeit*, XIII. Berlin, 1920
7 Ebbi, *Komödie von Max Beckmann*. Vienna, 1924
8 Foreword to catalogue: *M.B., Das gesammelte Werk*. Mannheim, 1928
9 'On My Painting'. Lecture given at the New Burlington Galleries in London, 1938. New York, 1941
10 'Letters to a Woman Painter'. Lecture given at Stephens College, Columbia, Missouri, in February, 1948; published in Peter Selz, *Max Beckmann*. New York, 1964. Also published in German: 'Drei Briefe an eine Malerin' P. Beckmann and P. Selz, *Max Beckmann, Sichtbares und Unsichtbares*. Stuttgart, 1965
11 'Ansprache an die Freunde und die Philosophische Fakultät der Washington University, St Louis, Missouri, 6 June 1950'. *In Memoriam Max Beckmann*. Frankfurt, 1953
12 'Aus Briefen Max Beckmanns'. *Das Kunstwerk*, X. 1956–7
13 *Tagebücher, 1940–50*. Compiled by Mathilde Beckmann, edited by Erhard Göpel. Munich, 1955
14 *Leben in Berlin, Tagebuch, 1908/09*. Edition by Hans Kinkel. Munich, 1966

II Selected monographs

15 Hans Kaiser, *Max Beckmann*. Berlin, 1913
16 Curt Glaser, Julius Meier-Graefe, Wilhelm Fraenger and Wilhelm Hausenstein, *Max Beckmann*. Munich, 1924
17 Heinrich Simon, *Max Beckmann*. Berlin and Leipzig, 1930
18 Franz Roh, *Max Beckmann als Maler*. Munich, 1946
19 Benno Reifenberg and Wilhelm Hausenstein, *Max Beckmann*. Munich, 1949
20 Erhard Göpel, *Max Beckmann, der Zeichner*. Munich, 1954
21 Erhard Göpel, *Max Beckmann in seinen späten Jahren*. Munich, 1955
22 Erhard Göpel, Max Beckmann: *Die Argonauten* (Reclams Werkmonographien). Stuttgart, 1957
23 Erhard Göpel, *Max Beckmann, der Maler*. Munich, 1957
24 L. G. Buchheim, *Max Beckmann*. Feldafing, 1959
25 Günther Busch, *Max Beckmann*. Munich, 1960
26 Hans Martin Freiherr von Erffa and Erhard Göpel (ed.), *Blick auf Beckmann. Dokumente und Vorträge*. Munich, 1962
27 Stephan Lackner, *Max Beckmann*. Berlin, 1962
28 Stephan Lackner, *Max Beckmann, Triptychon*. Berlin, 1965
29 Peter Selz, *Max Beckmann*. New York, 1964
30 Peter Beckmann and Peter Selz, *Max Beckmann, Sichtbares und Unsichtbares*. Stuttgart, 1965
31 Stephan Lackner, *Ich erinnere mich gut an Max Beckmann*. Mainz, 1967
32 Charles S. Kessler, *Max Beckmanns Triptychs*. Cambridge, Massachusetts, 1970
33 Friedhelm W. Fischer, *Max Beckmann, Symbol und Weltbild*. Munich, 1972